Beneath the Moon

FAIRY TALES, MYTHS, and DIVINE STORIES from AROUND the WORLD

Yoshi Yoshitani

TEN SPEED PRESS
California | New York

Contents

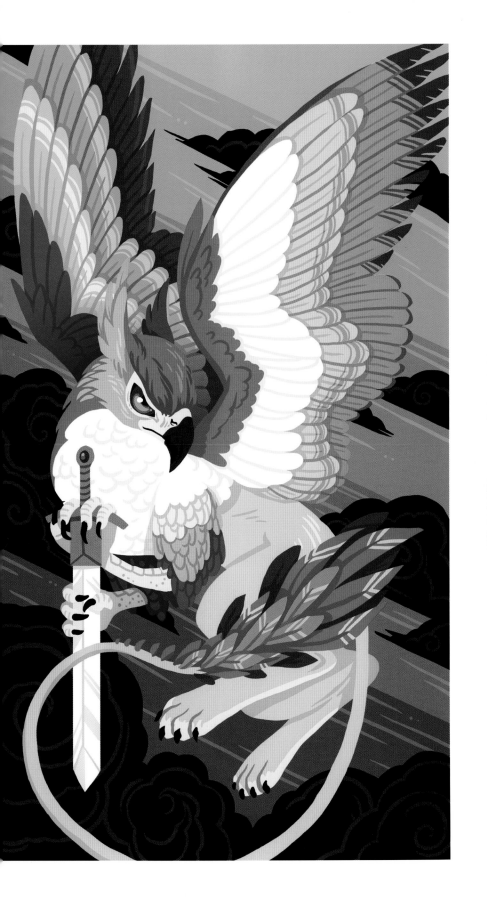

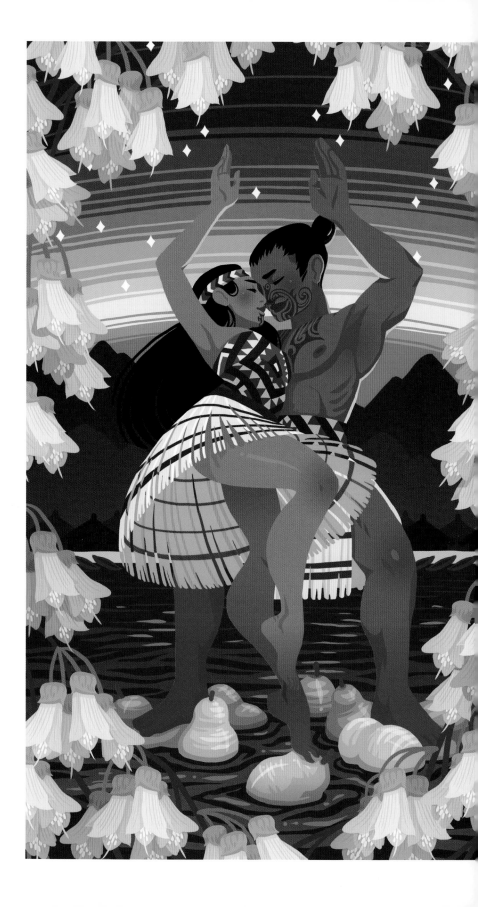

Introduction

I grew up caught between two cultures. My paternal side was from Japan—they ate rice with pickled plums and decorated their walls with woodblock prints of Shinto shrines. My maternal side came to America on the Mayflower—they ate meatloaf and decorated their walls with keys from their old family farm in Rhode Island. So often my two halves felt irreconcilably different, but the one thing they had in common was their love of stories.

From my paternal side I heard the fairy tales of Princess Kaguya, Peach Momotaro, and *Journey to the West*. From my maternal side I heard the stories of Cinderella, Puss in Boots, and Jack and the Beanstalk. While the settings were very different for these stories, the themes of bright young adventurers, forbidden doors, and promised lands were paralleled in many of them. I came to appreciate that my two very different heritages shared much in common in their hearts. Books of myths and fairy tales became a way for me to appreciate every part of me.

My experience of a mixed household is becoming increasingly common with each generation. Families raise their children in cultures different from the ones the parents grew up in, and more families blend together to create whole new experiences. As people are becoming progressively multidimensional and label-defying, it is ever more important to expand our understanding of each other. And the best way I have learned to appreciate differences and similarities is through stories.

This collection of stories is meant to serve as a small window into many different cultures. The average reader will recognize a few but many more will be unfamiliar. Some readers will see two or more pieces of themselves never seen together before. Many readers will discover new favorites. As much as possible I've tried to indicate each story's point of origin, but many stories are hard to pin down, especially those that traveled through trading thoroughfares such as the Silk Road. These stories may have been told in one culture about another culture or originated in yet a third culture. These mixes are confusing but ultimately reflect more about the storyteller, and inspire the stories we will tell tomorrow.

Finally, those familiar with the tarot will recognize repeating symbols such as cups, swords, coins, and staves in the imagery, and these seventy-eight illustrations form a tarot deck and booklet I created called the *Tarot of the Divine*. Like the tarot cards, each of these stories is equally relevant, and each offers valuable insights to the human experience.

I hope you enjoy this collection and leave wanting to learn even more about each other, all of us living beneath the same moon.

Yoshi Yoshitani

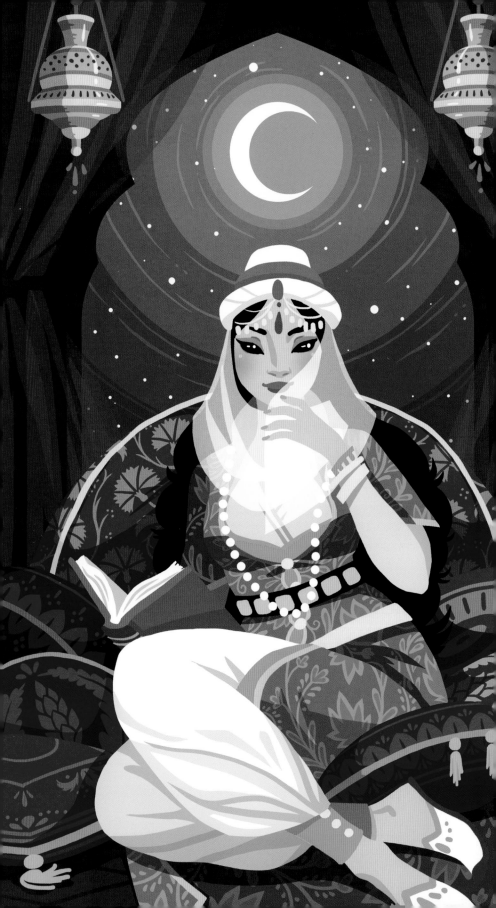

Scheherazade of 1001 Nights

TURKEY, ARABIC FOLKTALE

There once was a sultan who, upon his death, divided his domain between his two sons, Shahryar and Shah Zaman, and into two kingdoms. The brothers married two beautiful women and left to rule their respective domains. Although they lived far apart, they were still the best of friends and visited each other often.

One time when Shah Zaman was visiting Shahryar, Shahryar noticed how unhappy his brother was. When asked the reason, Shah Zaman confessed he had caught his wife cheating on him with another man, and in his rage, he had killed both his wife and the other man. Now suspicious of women, Shah Zaman discovered that Shahryar's wife was also cheating on Shahryar. Shahryar was furious. He ordered the execution of his wife and from then on married a new woman each night and killed her each morning before she could betray him.

The kingdom trembled in fear of Shahryar's wrath, until Scheherazade, the vizier's daughter, volunteered to become Shahryar's wife. When her night came, she cleverly asked Shahryar for one last wish, to see her younger sister, Dunyazad. Upon arrival, Dunyazad, prompted by her sister beforehand, begged Scheherazade for a story.

By the light of the moon, Scheherazade told a story so witty and interesting that when dawn broke and the story was only half done, Shahryar allowed her to live another night to finish her story. In this way, Scheherazade spent 1001 nights telling stories that were romantic, epic, moralistic, ridiculous, and righteous. Through these stories, Shahryar forgot his hate, became a compassionate monarch again, and relearned how to love with Scheherazade. He taught these lessons to his brother, Shah Zaman, who also forgave, and eventually married Dunyazad.

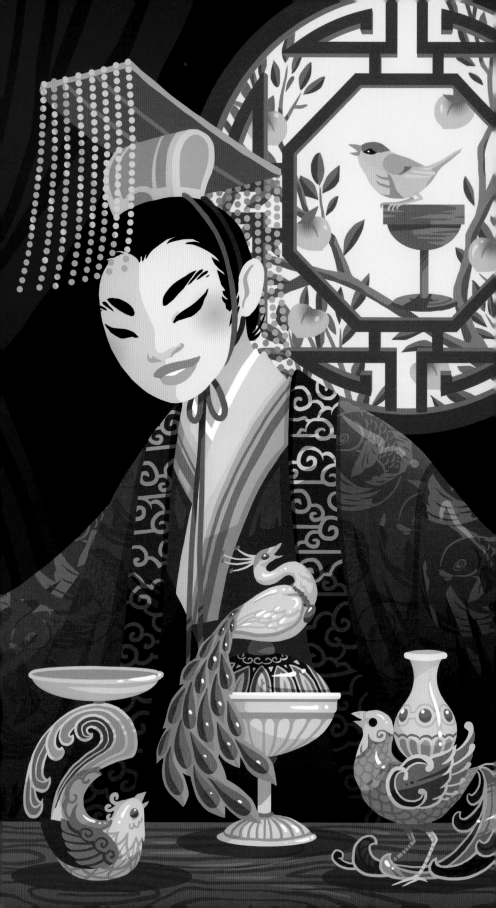

The Nightingale

CHINA, DANISH FAIRY TALE

Once long ago, the Emperor of China lived in a beautiful palace surrounded by beautiful gardens. Many travelers came to see the grandeur of his domain, but all agreed the most beautiful thing in the entire empire was not within the walls of the palace but in the nearby forest. For that is where the Nightingale sang with a voice so sweet and pure that all who listened could not help but stop and sigh. But though all the travelers knew this, the Emperor of China did not.

So it came as a great surprise to him when he read about the Nightingale in some books sent to him by the Emperor of Japan. The Emperor of China quickly summoned his courtiers and ordered them to bring the Nightingale before him. But none of his courtiers knew of the bird, nor did any of their subordinates. Finally, they found a young kitchen girl who declared she knew where the Nightingale roosted. She led the courtiers to the woods, and when they found the Nightingale, they asked her to return with them. She politely agreed.

That night the little bird was presented before the Emperor, who was surprised by her drab gray appearance. But when she began to sing, the entire court cried upon hearing the beauty of her voice. She was given a golden cage and tied with a golden string, and every day she sang for the Emperor and all his court.

Then one day a gift from the Emperor of Japan arrived. It was a beautiful gold-and-jewel-encrusted mechanical singing bird, and the court loved it even more than they loved the little Nightingale. The true bird disappeared, and the Emperor wound up the mechanical bird over and over. But eventually the golden bird broke and the Emperor grew sick. Lying alone on his deathbed, the Emperor waited in silence as Death approached him. It was then that the little Nightingale returned and sang a song so sweet that even Death was moved and let the Emperor live.

The Emperor thanked the Nightingale and tried to restore her to her gilded cage, but the Nightingale said that she would rather remain free to visit. And so she and the Emperor remained friends for all their days.

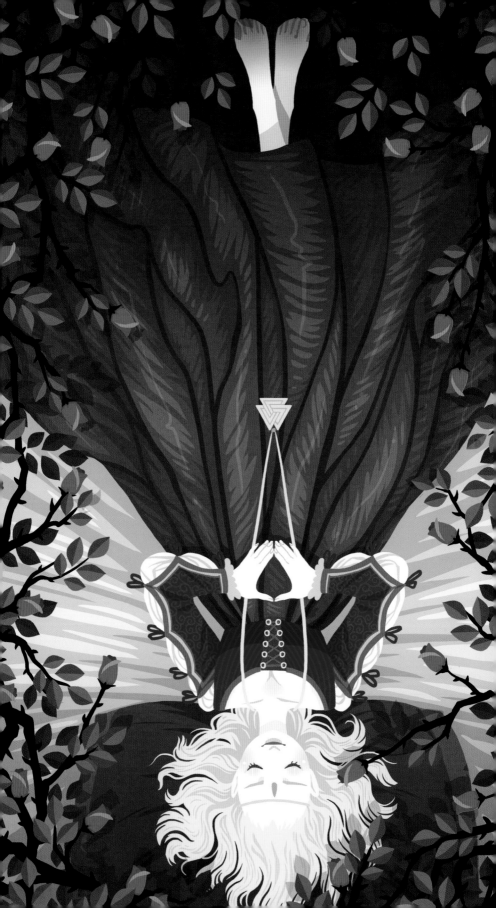

Sleeping Beauty

ITALY, ITALIAN FAIRY TALE

Once upon a time, there were a king and queen who, after many years of wishing for a child, were finally blessed with a baby girl. Seven good fairies were invited to a giant party in celebration. But the royal family forgot to invite the eighth fairy, and she became furious. While six of the seven good fairies gave the baby princess gifts of beauty and virtue, the eighth evil fairy cursed her to die by pricking her finger on the spindle of a spinning wheel. The last of the seven good fairies couldn't reverse the spell. Instead she changed the spell so that instead of dying, the princess would fall into a deep sleep and not wake until she was kissed by a true prince.

Fearing for his daughter's life, the king ordered every spindle in the kingdom burned. This precaution worked for sixteen years, until one day, while the king and queen were out, the princess found an old woman spinning wool in a forgotten part of the castle. Curious, the princess approached the spindle and accidentally pricked her finger. When the king and queen returned, she was already deeply asleep.

Saddened, the king and queen ordered the princess be laid in the most beautiful bed in the tallest tower. Then the good fairies returned and put the whole castle to sleep and grew thorns and brambles all around to protect it. And so the castle and all its inhabitants lay dormant for a hundred years until a curious young prince finally approached it.

The prince had heard rumors of the sleeping princess, and he dared to battle the brambles and scale the high walls all the way up to the princess in the tallest tower. The prince was mesmerized by her beauty, and with his kiss, she awoke. They fell in love, and as they descended the stairs, the rest of the castle woke up, too. They were soon wed, started a family together, and lived happily ever after.

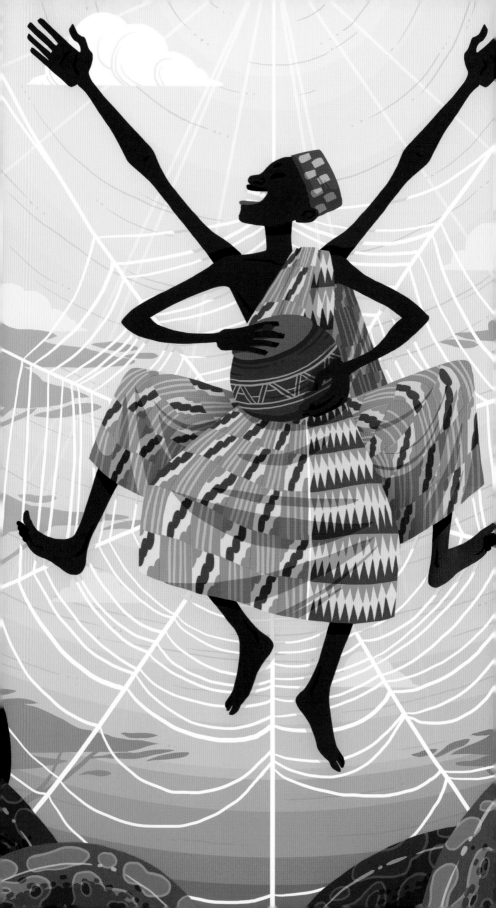

Anansi

Anansi was a tricksy spider who would constantly get himself in and out of trouble. There are many, many stories of Anansi and the mischief he caused, but one of the most famous is Anansi and All the World's Stories.

In the beginning of the world, the Sky-Father, Nyame, had all of the world's stories locked up possessively. Anansi the Spider thought that this was very boring. He used his sticky string to climb all the way up in the sky to Nyame's home and asked him to sell his stories. Nyame was impressed with the Spider for reaching him when no other animal could, but he still refused to sell the stories. After debating for a while, Nyame finally agreed to give Anansi the stories if he captured and brought back the four most dangerous creatures in the world: Onini the Python, Osebo the Leopard, the Mmoboro Hornets, and the invisible Mmoatia.

With Onini, Anansi pretended to doubt the python's true length. He then offered to tie him straight to a stick to measure him, which subdued the python. With Osebo, Anansi dug a pit that the leopard fell into. He then offered him webbing to climb out and hopelessly tangled the giant cat in his string. With the Mmoboro Hornets, Anansi faked a rainstorm. He then offered them safety inside a hollowed-out gourd, capturing them. With the Mmoatia, Anansi made a sticky doll that ate sweets. He then manipulated the doll into being so rude that the Mmoatia slapped the doll and got stuck.

Anansi returned to Nyame with Onini tied to a stick, Osebo caught in his web, the Mmoboro trapped inside the stoppered gourd, and the Mmoatia glued to a sticky doll. Nyame had to concede defeat and made Anansi the Master of All Stories.

Note: Anansi's outfit here is a Kente cloth with the pattern that reads "obi nkye obi kwan mu si," meaning, "sooner or later you will get into the path of the other."

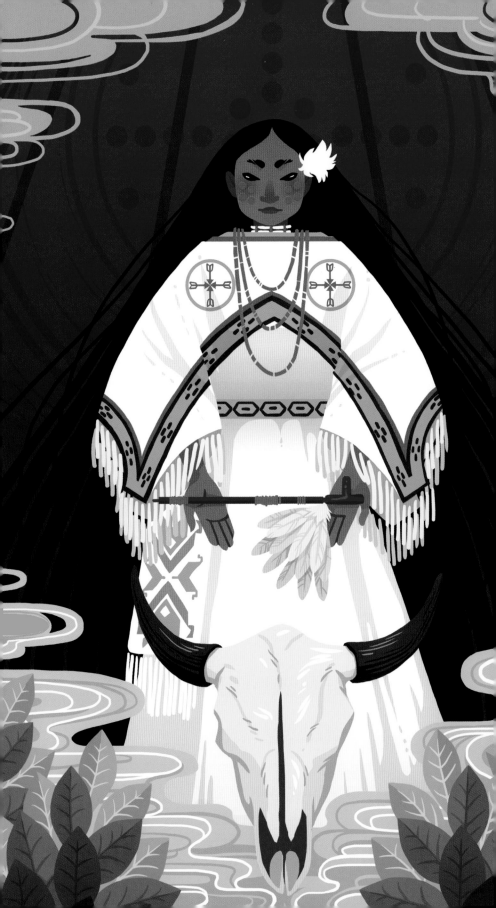

White Buffalo Woman

Long ago, there was no game to be found, and the Lakota Sioux were starving. The chief of the Lakota kept sending out scouts farther and farther, until one day, two of his scouts saw a beautiful young woman in white buckskin. She approached them by floating instead of walking, which caused one of the men to perceive she was *waken*, or holy, and deserved to be treated with respect and deference. The other man only lusted after her. He approached her arrogantly and treated her with impudence, desiring to make her his wife.

When he touched her, he was surrounded by a cloud of white smoke. When the smoke cloud finally dispersed, only a pile of bones was left where the man had previously stood. The first man quaked in fear, but the beautiful woman reassured him, for she saw no ill motives in his heart. She told him in his own language to go back and tell his people that she was coming. The young man returned to his people and called for a council, preparing for the arrival of the divine woman.

After four days, a white buffalo calf approached and rolled over four times. It turned black, then yellow, then red, and finally into the beautiful White Buffalo Woman. She stayed with the people for four days, teaching them sacred songs, dances, and ceremonies and giving them counsel on living as a people. On the last day, she gave the people the *chanunpa*, or sacred pipe, to cultivate peace and understanding. She taught them the correct prayers and taught everyone their place and roles in the sacred hoop of life. Finally she left, rolling on the ground four times. She turned into a yellow buffalo, a red buffalo, a black buffalo, and finally a white buffalo calf. As she disappeared over the horizon, a large herd of buffalo appeared, and their bodies supplied the Lakota with everything they needed. White Buffalo Woman taught that by uniting the earthly with the divine, all that was needed would be provided.

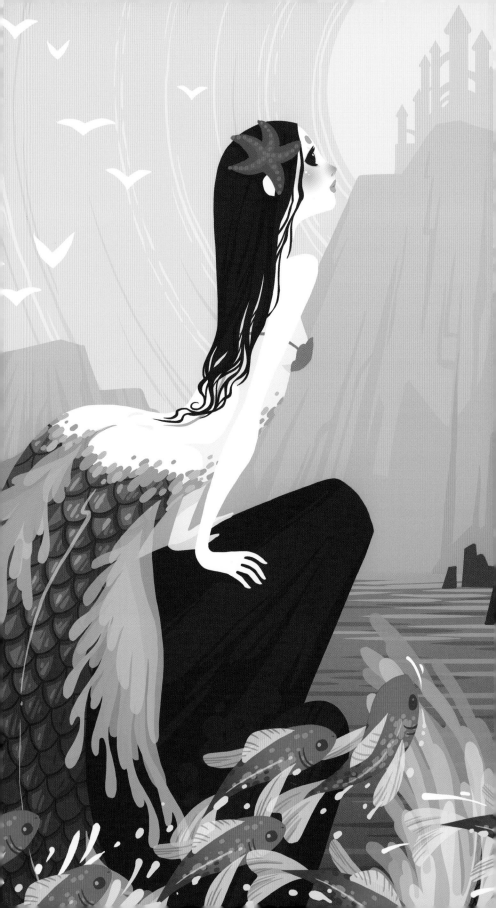

The Little Mermaid

DENMARK, DANISH FAIRY TALE

There once was a little mermaid princess who lived in a beautiful castle beneath the sea. And although she had many beautiful things, what she wished for most of all was to see all the things on the earth above the waves where her fins couldn't take her.

One day, while the little mermaid was swimming close to a passing ship, she happened to see a handsome prince walking the deck. She was instantly charmed by his good looks and sweet disposition and then worried by the ominous storm that approached his ship.

The vessel tried its best to withstand the storm but eventually broke apart on the crashing waves. After the weather calmed, the little mermaid found the prince's unconscious body floating in the debris and bore him back to land.

Leaving him safely on a beach, the little mermaid saw another girl run to his body and wake him. His first smile was for the girl, not the little mermaid, and this made the little mermaid miserable. She returned to her sea kingdom and sought the aid of the witch who lived there. She told the witch that she wanted to walk on land. The witch tried to dissuade her, telling the little mermaid her feet and legs would always hurt. The witch also warned that the magic required that the mermaid gain the love of a human; otherwise, she would die and turn into sea foam. The little mermaid agreed. As payment for the spell, the witch took the mermaid's voice in exchange for turning her tail into legs.

Walking for the first time on land, the little mermaid soon found her prince, fully recovered from the shipwreck. But in that time, he had fallen in love with the girl who found him on the beach. The prince befriended the little mermaid, but without a voice, she couldn't tell him who had actually saved him. She could only watch as he married the girl, and she, still loving him, died and turned into sea foam.

Crane Wife

JAPAN, JAPANESE FAIRY TALE

There once was a poor woodcutter who came across a beautiful crane caught in a hunter's trap. He felt sorry for the graceful bird, so he carefully set it free. Once released, the bird looked deep into the man's eyes before flying away.

Days later, a lovely woman appeared at his door asking for shelter. She was so charming and beautiful that the man asked her to marry him. The mysterious woman readily agreed, for she had fallen in love with the man as well. A short time later, they were married, but life was not easy. The man was still poor, and now he tried to work twice as hard to feed both himself and his beautiful wife.

The woman saw this and offered to make fabric to sell. She asked only that her husband never come into her room while she worked. Confused, he agreed. A few days later, his wife, looking weak and tired, presented him with the most sumptuous fabric he had ever seen. He took the work to market and sold it for a lot of money, which he was able to use to buy them many good things.

From that day on, the couple lived well. The wife would retreat to her room and secretly work, emerging later looking a little more sickly but with fabric even more beautiful than the last. The husband would take the fabric to market and sell it for ever higher prices, returning with goods and gifts that made them very wealthy.

Though his life was easier, the man began to worry for his wife, who was looking ever more frail. Finally, his curiosity could take no more. One night while she was working, he cracked the door open and peered in. He discovered that his wife was a crane—a crane who had been slowly and painfully plucking her own feathers and weaving them to create the beautiful fabric.

He gasped, and she turned to see that he had learned her secret. She was angry that he broke his promise and mortified that he had seen her as a crane. And so she took flight and never returned to her husband.

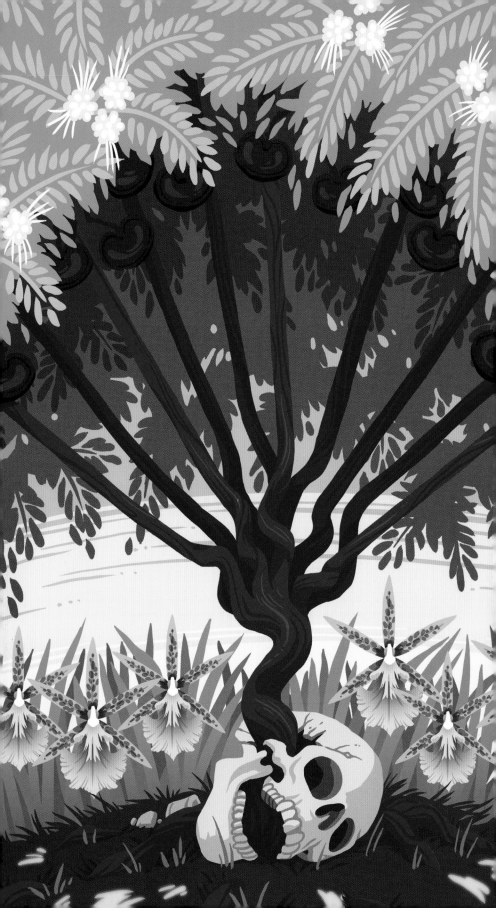

Timbó Tree

There once was a man named Saguaa who was the leader of his tribe. He had a single daughter named Tacuaree whom he loved very much. They were both good people beloved by the tribe, so it was not unexpected that Tacuaree had many suitors. But Tacuaree had eyes only for a man from another tribe. Though it saddened Saguaa to have his dear daughter live so far away from him, he also respected her wishes and let her go with his blessing.

Days, weeks, and then months passed, and still Saguaa had not heard from his daughter. He began to fear she was in danger, and finally he set out to see her. He went to the village that Tacuaree had moved to but found nothing but the remnants of ruin where thriving life should have been. The village had been attacked by an unknown enemy, and all the people were missing entirely. Distraught, Saguaa began searching for his daughter.

The trail soon ran cold. With no other leads, Saguaa placed his ear to the ground, hoping to hear the sounds of stomping feet or other noises that could tell him where they had gone. He heard nothing, so he got up, moved on, and then stopped again, listening for anything. He never asked for help and never stopped searching.

Months later, his tribe found him dead, still lying with his ear to the ground listening for his daughter. But a strange thing had happened. A plant had grown out of his ear. The plant grew and stretched and eventually became a tree. The tree flowered, and its fruits looked like human ears.

From that day on, the timbó tree came to represent a father's undying love for his daughter, for he is still listening for her to this day.

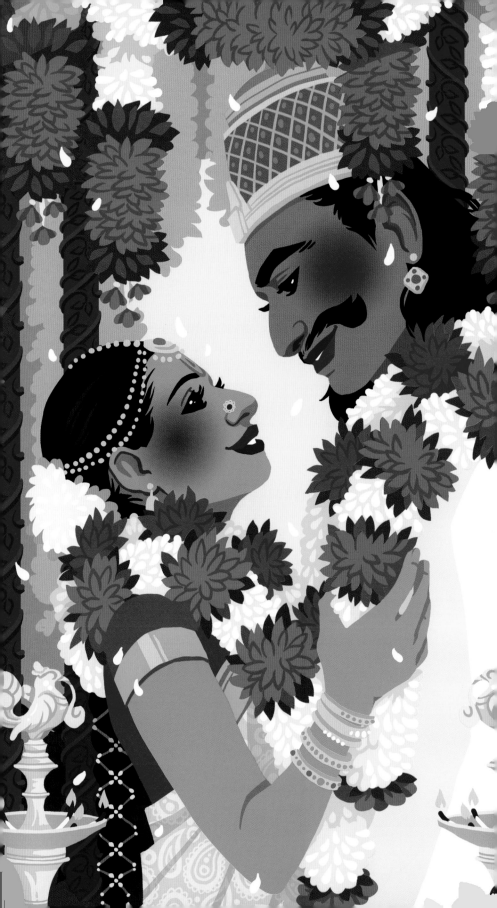

Mohini and Aravan

TAMIL INDIA, HINDU EPIC MAHABHARATA

The Mahabharata, a Hindu mythical and historical epic, primarily documents the five Pandava brothers and their battle with their cousins, the Kauravas, for succession of the throne of Hastinapura in the Indian kingdom of Kuru. The battle was called the Kurukshetra War, and it lasted for eighteen days and resulted in the deaths of millions on both sides.

In the beginning of the battle, the Pandava side was vastly outnumbered, and failure seemed a distinct possibility. Krishna, the eighth incarnation of the Vishnu, the preserver and protector god, supported the Pandavas. He suggested that someone willingly sacrifice themselves to Kali, Goddess of Time and Destruction, in order to ensure a victory for the Pandavas. Aravan volunteered.

Aravan was the son of Arjuna, the third Pandava brother, and Ulupi, the Naga (snake) Princess. He was a great warrior who did not fear death, but he did wish to be married before he died. This is because he wished for the cremation and funerary rites of a married man versus a bachelor, who is buried. Unfortunately, no woman wanted to marry him, as becoming a widow was a terrible fate for anyone. So Krishna agreed to marry him. He took on his rarely seen female form, Mohini, married Aravan, and spent the night with him. (Their wedding is celebrated to this day in Tamil, where Aravan is the patron god of the transgender Hijra communities.)

Aravan then charged forward into the fight knowing he would eventually die on the battlefield. He fought and defeated many key members of the opposing army. Then the eldest Kaurava summoned the giant Alamvusha to fight Aravan. Aravan assumed his serpent form, Shesha, but Alamvusha assumed his Garuda (giant eagle-man) form and ultimately beheaded him. Eventually Aravan was avenged, and the Pandava brothers won the war.

Mohini acknowledged Aravan's death and her widowhood by breaking her bangles, beating her breasts, and discarding her bridal garments before finally returning to the form of Krishna.

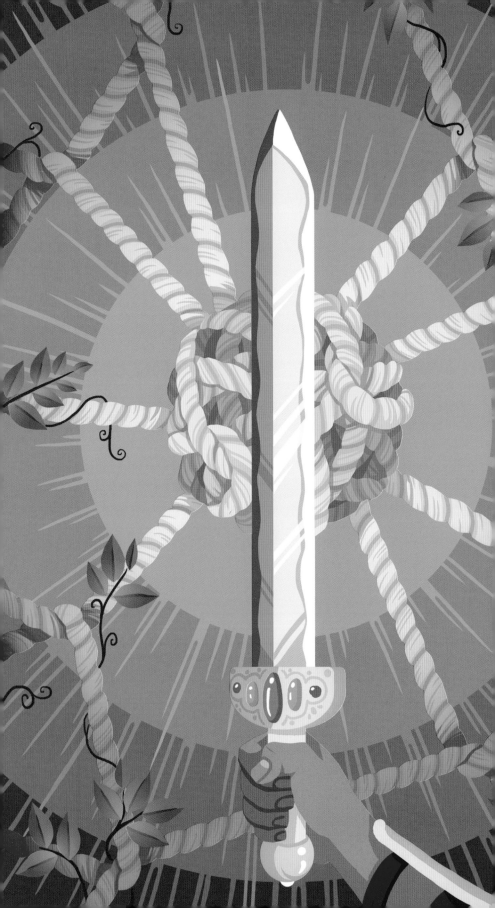

Alexander the Great and the Gordian Knot

TURKEY, GREEK LEGEND

In the western part of Anatolia, there once lay a kingdom called Phrygia. Legends say that at that time, the Phrygians were without a king, so the oracle Telmissus told the people that the next man to enter their capital city driving an oxcart should become king. The people agreed, and when a farmer, Gordias, entered on an oxcart, they declared him king. The city was named Gordium, and Gordias's son, Midas, who would later become King Midas of the golden touch, dedicated the oxcart to Zeus. Midas tied the cart to a post with a giant and intricate knot that was so complicated and entangled it was impossible to see how it was fastened. It was called the Gordian Knot.

Generations passed, and Phrygia was no longer its own country but a province of the Achaemenid, or Persian, Empire. In this time, a new oracle prophesied that whoever could unravel the Gordian Knot would be destined to become the ruler of all of Asia. The knot sat impossibly tangled until the arrival of Alexander the Great.

Alexander the Great was born to the king of Macedon, Phillip II, and his wife, Olympias. His father was assassinated when Alexander was only twenty, and he became the king of Macedon shortly after. He then consolidated his power and was awarded the generalship of Greece. He took his huge army, pushed into the Achaemenid Empire, and won neighboring lands Sardis and Caria before taking Gordium.

Arriving in his newly conquered city, Alexander found the cart still tied to the post with the giant, impossible knot. And though Alexander tried, he could not untangle the giant mess. Finally, Alexander stepped back and reasoned that it made no difference how the knot was loosened, just that the cart was freed. So he drew his sword and sliced the rope in half with a single stroke.

Alexander went on to fulfill the prophecy, conquering Asia as far as the Indus and Oxus and living forever as one of the greatest generals in all of history.

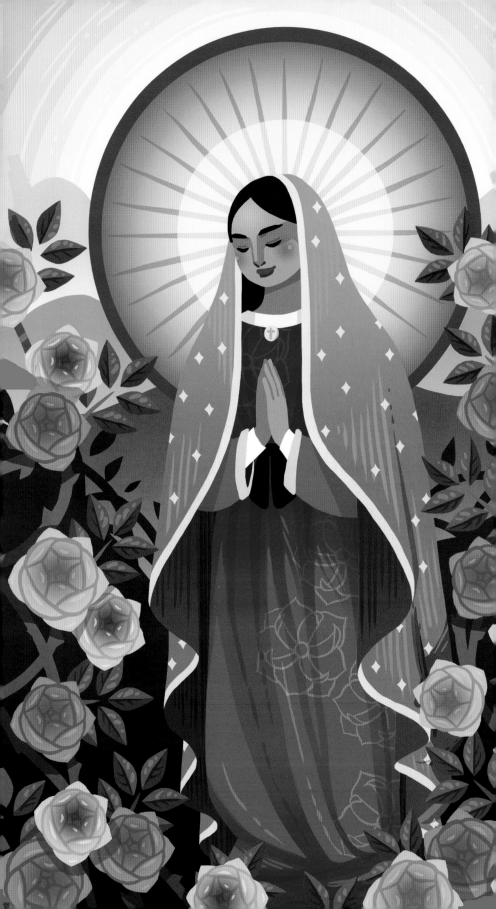

Our Lady of Guadalupe

MEXICO, CATHOLIC SAINT

One December morning, a woman of mixed heritage appeared before native Mexican peasant Juan Diego and spoke to him in his native tongue, Nahuatl, the language of the Aztecs. She said she was the mother of the very true deity, the Virgin Mary, and asked for a church to be built in her honor on that very hill.

Juan Diego sought the archbishop of Mexico City, Friar Juan de Zumárraga, to tell him of the occurrence. The archbishop was skeptical, but when Juan Diego saw the woman again, and she again told him to build the church, the archbishop asked for a miracle to be performed to prove her identity. She agreed and told Juan Diego to return to the hill the next day. But the next day Juan Diego was forced to go to his dying uncle, Juan Bernardino. The day after, the woman caught Juan Diego trying to sneak around the hill he was supposed to meet her on. When he guiltily admitted to his reasons, the woman chided him, saying, "Am I not here, I who am your mother?" She told him to climb the hill and gather the flowers there.

The hill, normally barren in December, was bursting with Castilian roses, native to Spain, not Mexico. The woman helped Juan Diego gather the roses in his cloak. When he presented the full blooms to the archbishop, they found the cloak covered in the image of the woman. Juan Diego returned to his uncle and found Juan Bernardino fully healed by the gifted woman. She then asked to be known as Guadalupe. The archbishop accepted these miracles and began construction of a chapel on Tepeyac Hill.

Our Lady of Guadalupe has come to represent *mestizos*, or people of mixed native and European heritage. She is a symbol of peace, healing, and unity.

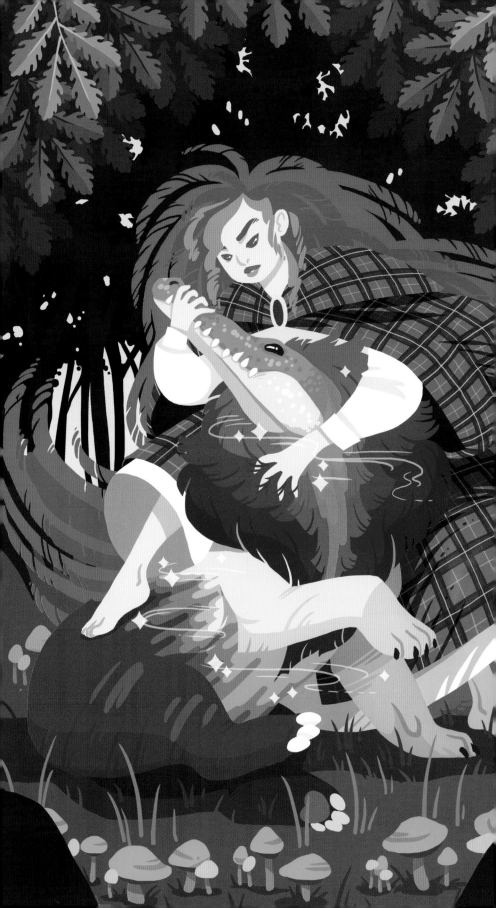

Tam Lin

There once was a girl named Janet who used to take a shortcut through the woods of a deserted estate. One evening while taking this shortcut, she met a man so beautiful and dressed so grandly, she thought he was a fairy prince. They started talking and then flirting all through the night, and Janet went home very well pleased. But a few months later, she realized she was pregnant. Her family told her she had only a couple of options: to get rid of the baby or to get married. Janet ignored this and went in search of the father of her child.

Finding him in the same forest, Janet confronted him. He told her his name was Tam Lin and that he wasn't a fairy but had owned the estate before being captured by the Fae. Upon further inquiry, Tam Lin said he could be freed but only if Janet grabbed him off his horse and didn't let him go.

Janet agreed, and the next night she waited and watched as the Fairy royal procession passed. She saw many beautiful courtiers and the Fairy Queen who had trapped Tam Lin, and finally Tam Lin himself. Leaping from her hiding place, Janet grabbed Tam Lin and held him tight. The Fairy Queen laughed and proceeded to transform Tam Lin into every animal imaginable, and even a few that were never before seen by Janet. One was Ammit, a creature that was part lion, part hippopotamus, and part crocodile and who ate impure hearts.

After hours of this, and just as Janet didn't think she could hold on any longer, the dawn rose, the Fae vanished, and the spell was broken. Janet let go of Tam Lin, human and free again, and the two soon wed and had many more children in Tam Lin's restored estate.

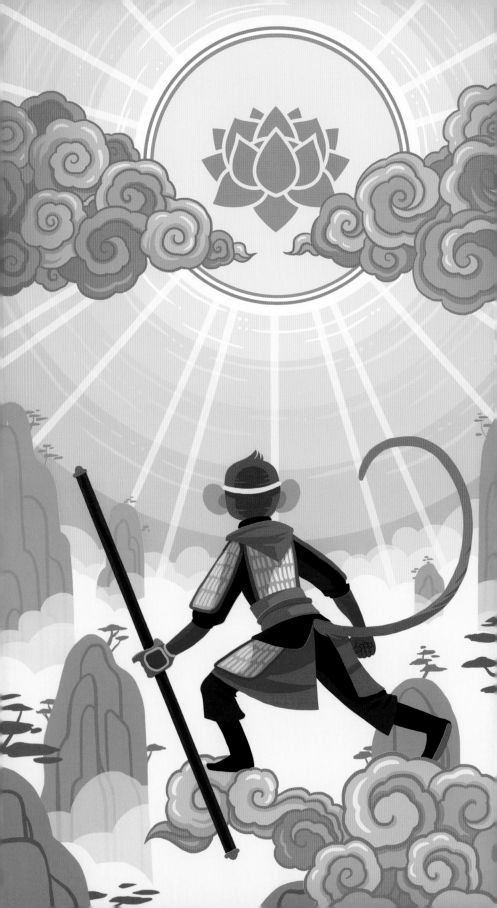

The Monkey King, Sun Wukong

CHINA, CHINESE MYTHOLOGY

There once was a magic rock on top of a mountain that split open to reveal a monkey inside. The magic monkey joined a band of normal monkeys and soon became their king, naming himself the Handsome Monkey King, Sun Wukong. He proceeded to defeat the dragons of the four seas in battle. In his victory, he was given the magical golden-banded staff, Ruyi Jingu Bang; a golden chainmail shirt; a phoenix-feather cap; and cloud-walking boots. With all his new power, he established himself as an invincible demon, even going so far as to storm into Hell and erase his name from the Book of Life and Death.

Heaven was impressed enough to invite him to the celestial court but not enough to treat him with respect. Furious, Sun Wukong ate the peaches of immortality and the pills of longevity and drank the royal wine. He gained even more powers and abilities and proceeded to single-handedly defeat every warrior in Heaven. Heaven finally asked Buddha for help.

Buddha bet Sun Wukong that he couldn't escape the Buddha. The Monkey King smugly accepted and flew to the ends of the earth, where he graffitied the five pillars. He leapt back and landed in the Buddha's palm. There he was surprised to find that the five "pillars" he had painted were in fact the fingers of the Buddha's hand.

Buddha then trapped Sun Wukong beneath a mountain for five hundred years, releasing him only to assist the monk Tang Sanzang on a journey to the West to retrieve the Buddhist sutras. The two were joined by two others who had to atone for their crimes. The small group experienced many tribulations and trials, during which Sun Wukong learned many virtues and the teachings of Buddha, before successfully accomplishing their mission and returning to China. Finally, Sun Wukong faced Buddha once again. At last he was freed and granted Buddhahood for his service and strength.

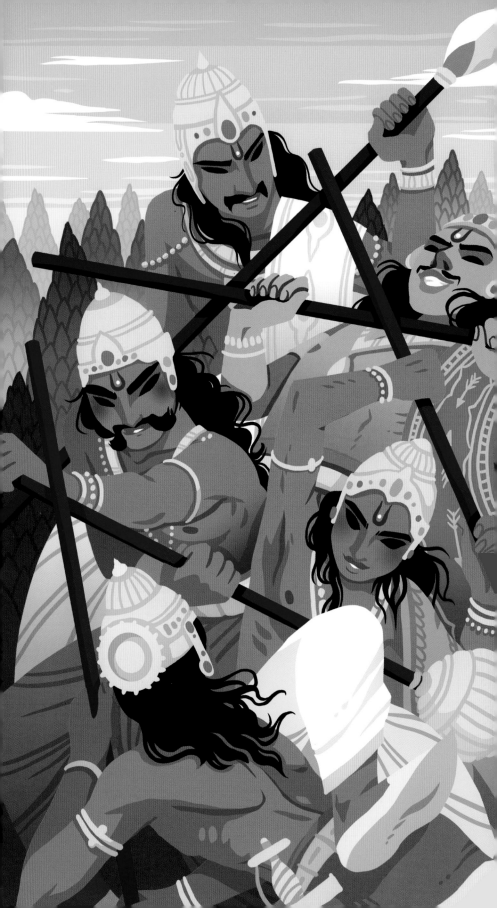

The Pandavas

INDIA, HINDU EPIC MAHABHARATA

The king of Hastinapur, named Pandu, once accidentally shot and killed Sage Rishi Kindama and his wife, who were making love in the form of deer. With his dying breath, the sage cursed the king, declaring that he would die if he ever loved his wives or any other woman. In penance, King Pandu renounced his throne and went into exile with his wives, Kunti and Madri.

With King Pandu unable to father children, Kunti asked the gods Yama, Vayu, Svarga, and the Ashvin twins to father her and Madri's children. They gave birth to five sons, and these five brothers—Yudhisthira, Bhima, Arjuna, Nakula, and Sahadeva—became known as the Pandavas.

One day Pandu coveted his wife Madri and, just as the curse promised, he died. The Pandava brothers then returned to Hastinapur in order to reclaim the throne for their brother Yudhisthira. But Pandu's brother Dhritarashtra had been reigning in their absence. During those years, Dhritarashtra and his wife, Gandhari, had one hundred sons, known as the Kauravas, with the eldest, named Duryodhana, intending to inherit the kingdom.

Sensing a rivalry, Duryodhana built a flammable house and asked the Pandavas to stay in it. The brothers managed to escape through a tunnel and into the forest before Duryodhana set fire to the house. In the forest, they soon heard about an archery contest to win the beautiful Princess Draupadi. Arjuna then won the archery contest, and by their mother's desire that the brothers share everything equally among them, all five Pandavas married Draupadi.

The Pandavas returned home, and Dhritarashtra split the kingdom in two, giving the prosperous half to his son, Duryodhana, and the barren half to his nephew Yudhisthira. The Pandava brothers developed their half so well that the lands began to rival the heavens, and Duryodhana became jealous. Using magical dice, Duryodhana managed to trick Yudhisthira into condemning the Pandavas and their wife into thirteen years of exile. The Pandavas were furious with their brother, but they managed to stay unified and used the time to prepare for war. Upon returning from exile, they initiated the Kurukshetra War, which ended with the death of all one hundred Kauravas and the ascension of Yudhisthira to the throne.

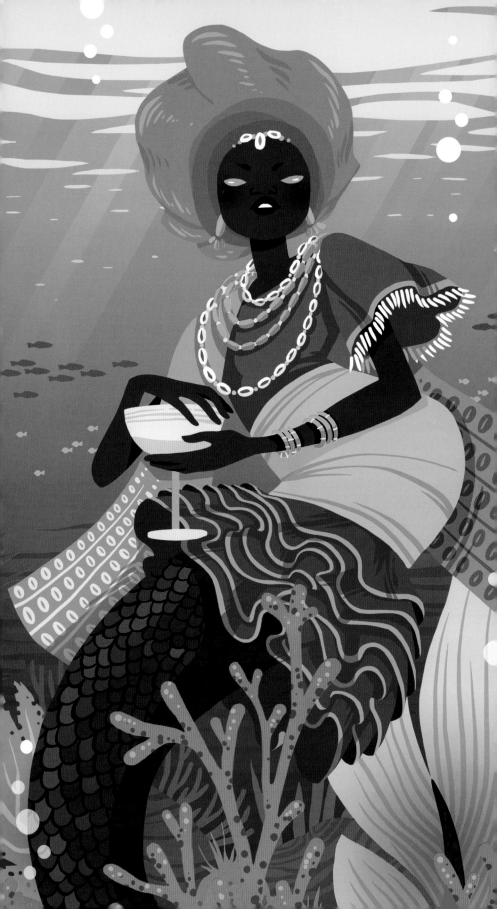

Yemoja

NIGERIA, YORUBA DEITY

Yemoja is a Yoruban *orisha*, or deity, of rivers and surface ocean waters. Though originally worshipped in Nigeria as part of the African diaspora, she is celebrated in places in the Americas such as Cuba, Brazil, and Uruguay, all with different stories and powers attributed to her.

Yemoja existed at the beginning of creation, and all life and all orishas come from her waters. At the very start, she married Oko, the orisha of farming. But she became unhappy with him and left him to live in the sea, where the orisha Olokun initiated her to the way of the oceans. She became in charge of rivers and surface waters, the parts teeming with life, and was named *Yeye omo eja*, or "mother of fishes," for her countless progeny. Olokun, for his part, became in charge of the deep dark ocean, and only Yemoja is able to soothe his wrath when he creates tidal waves and storms.

After a time, Yemoja returned to the surface seeking a new husband and more children. She at various points married Obatala, Orula, Babalu, Aye, Orisha, and in some stories, Oyun. She then married the orisha Aganyu, and they had a son named Orungan. Unfortunately, Orungan began to covet Yemoja and tried to force himself on his mother. She refused him, and instead her water broke and she flooded the world while giving birth to fourteen orishas and the first humans. She then returned to the ocean and is now seen only rarely by people.

Though she is infrequently seen, Yemoja still cares deeply for her worshippers, especially women and children. She governs conception, childbirth, infertility, parenting, child safety, love, and healing. She oversees secrets, wisdom, the moon, and the unconscious. Her particular symbols are cowrie shells and the color blue. She is known to be particularly kind to those who drown at sea in her waters, including those who were taken far from their homes.

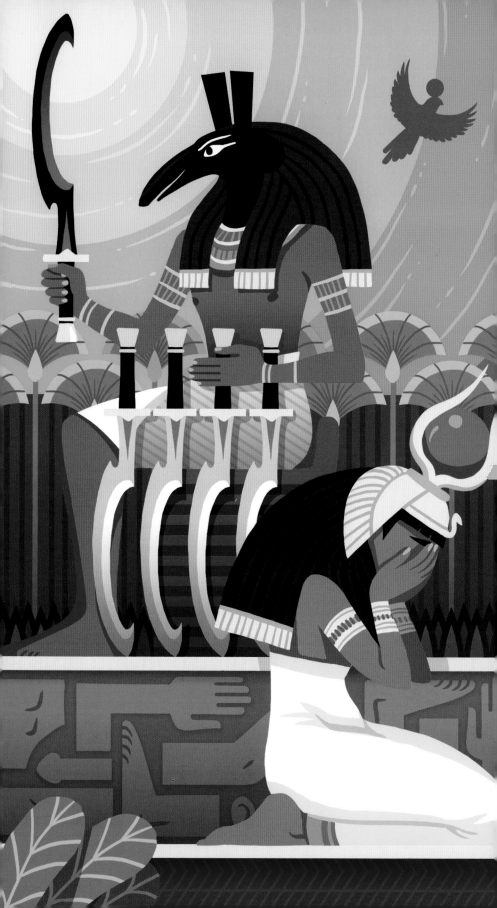

Osiris, Set, and Isis

EGYPT, EGYPTIAN MYTHOLOGY

In the beginning, Ra rose and created the world. He created the earth god, Geb, and the sky goddess, Nut, and together they produced the gods Osiris, Isis, Set, and Nephthys. Ra ruled Egypt for a while, but eventually his kingship passed to Osiris. Osiris ruled with his queen, Isis, and they ruled by the rule of *maat*, or natural and righteous order. But Set brought chaos and destruction, murdered Osiris, chopped him up, and scattered the pieces of his body throughout Egypt.

Isis cried, and her tears flooded the Nile, bringing life to its banks. She fled from Set and, with the help of Nephthys, flew as a falcon to find the pieces of her husband. When all the pieces were collected, Isis called upon Thoth, god of magical healing, and Anubis, god of funerary rights, to restore her husband. They came together and used their powers to turn Osiris into the first mummy.

Isis flew above Osiris and blew life into her husband with the beating of her wings. She then laid with him and became pregnant. Osiris left to rule over Duat, the land of the dead. Isis, meanwhile, hid in a thicket of papyrus until giving birth to their son, Horus.

The young Horus was vulnerable, and Set sent many dangerous creatures to poison or hurt him. He endured everything from scorpion stings to snakebites to stomachaches. Isis, with magical healing powers of her own, repeatedly cured and saved her child and thus gave these cures to the people of Egypt.

Eventually Horus grew up and challenged Set for his kingship. To determine who should rule, the contests were judged by the Ennead, or group of Egyptian deities. The duels were long and brutal and resulted in the loss of Horus's eye. After many years of warring, Horus finally rose victorious. Set was then banished to the desert, and Horus ruled justly as his father did before him.

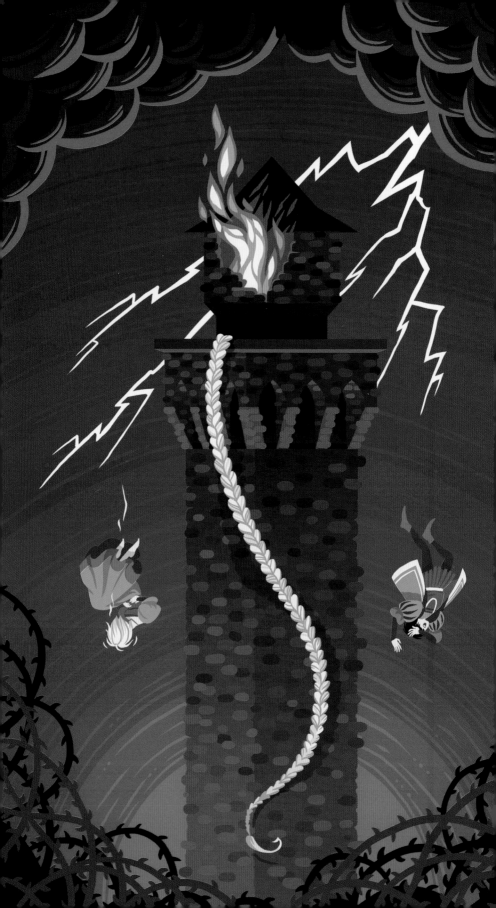

Rapunzel

GERMANY, GERMAN FAIRY TALE

There once was a poor couple who dearly wanted a child. When the woman became pregnant, she was filled with an insatiable craving for the leaves of her neighbor's rapunzel plant. Unfortunately, their neighbor was a witch, so the husband was too scared to ask for some. But his wife soon became sick and began to die for want of the plant, so her husband silently scaled the witch's garden wall and stole some rapunzel. But before he could make his escape, the witch caught him. The witch promised to give the man all the rapunzel his wife wanted, but in exchange they would have to give the newborn to her. The terrified man agreed, and nine months later a baby girl named Rapunzel was born and reluctantly given to the witch.

Rapunzel grew to be very beautiful, with long golden hair. When she turned twelve, the witch locked her in a tower with no stairs or doors, only one room and one window. The tower was surrounded by thorns. To visit the girl, the witch stood at the base of the tower and shouted up to Rapunzel to let down her hair so that she could climb up the long tresses. One day a prince heard Rapunzel's lovely singing and saw the witch visiting her. After the witch left, the prince ascended Rapunzel's tower. She was shocked at first, but soon they talked, fell in love, and agreed to marry. They planned Rapunzel's escape, and the prince left to get her a silk ladder.

When the witch returned, she instantly detected Rapunzel's deception. Furious, she chopped off Rapunzel's hair and banished her to the wastelands. When the prince returned, the witch pushed him from the tower, where he landed in the thorns and lost both of his eyes.

The prince wandered blind for many years until one day he heard Rapunzel's beautiful singing. He followed her voice, and they were reunited. Rapunzel cried happy tears, some of which fell over his eyes, and his vision was restored. They returned to his kingdom and lived happily ever after.

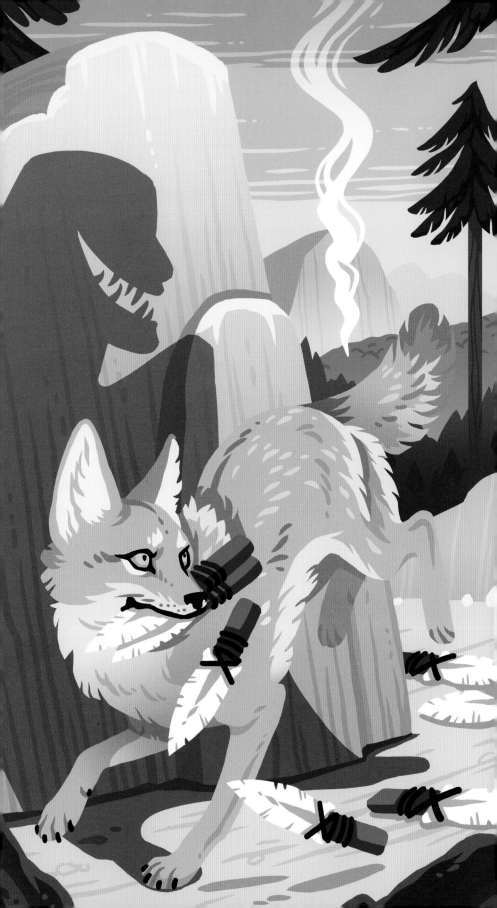

Coyote

There are no buffalo on the western side of the Rocky Mountains, and that is Coyote's fault. Coyote is a trickster, and while he has done many good things for the world, he has also done just as much bad.

Coyote was walking along on the plains to the east of the mountains when he found the skull of Buffalo Bull, who had been huge and terrifying to Coyote in life but weak and pathetic in death. Coyote laughed and mocked the skull, kicking and spitting on it before walking on with a delighted yip. It wasn't long before Coyote heard a powerful rumble and looked over his shoulder to realize he was being chased down by Buffalo Bull himself, come back to life. Coyote used his magic to form three trees that he could scramble up. Buffalo Bull toppled two of the trees with his horns before Coyote managed to convince Buffalo Bull to take a break to smoke with him before tearing down the third tree.

Coyote distracted Buffalo Bull, asking him questions. He learned that Buffalo Bull had died at the hands of Young Buffalo, who had stolen Buffalo Bull's fine herd. Coyote offered to make Buffalo Bull new horns that he could use to defeat Young Buffalo. Buffalo Bull agreed and decided not to kill Coyote. Coyote made him pitch-black horns that were heavy and sharp, and with these, Buffalo Bull returned to his herd and defeated Young Buffalo.

Buffalo Bull rewarded Coyote with a young cow and told him that if he never killed her, she would supply him with meat forever. Coyote only needed to slice off the fat—not the muscle as that would hurt the cow—with a knife, then rub ashes on the wound to heal it. Coyote ate this way for many days, returning to the western side of the mountains. But eventually Coyote grew tired of eating only fat and desired bone marrow and liver. He thought Buffalo Bull wouldn't find out. However, when he killed the cow, magpies and crows swarmed and stole every last bit of her. Ashamed, Coyote returned to Buffalo Bull and discovered the cow among his herd again. Buffalo Bull refused to give Coyote a new cow, so Coyote was forced back to the west, where no buffalo roam to this day.

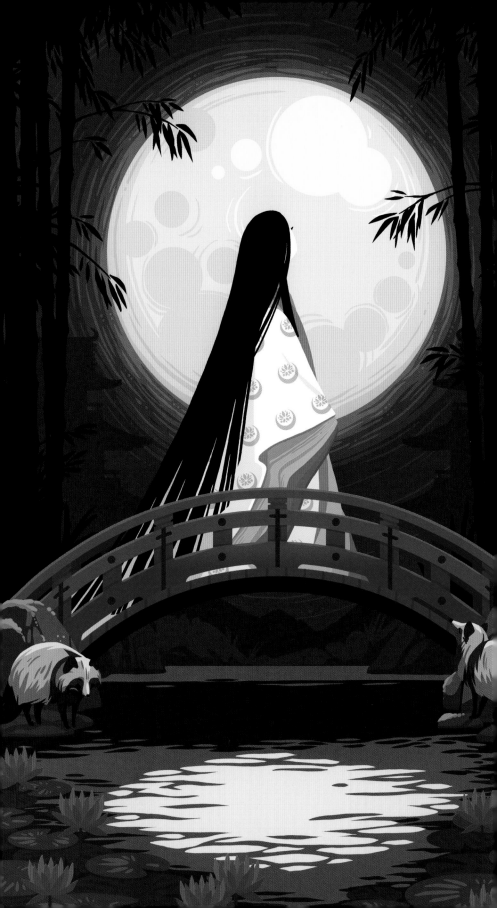

Princess Kaguya

JAPAN, JAPANESE FAIRY TALE

One day, an old childless bamboo cutter came across a mysteriously glowing stalk of bamboo. He cut it open and found a lovely, tiny baby girl inside. Delighted, he took her home to his wife, and they raised her as their own, naming her Kaguya. From then on, every bamboo stalk he cut down had gold in it—gold he used to become rich and give his daughter a fine education and beautiful clothes. As Kaguya grew older, she grew more radiant, and soon word of her magnificence spread.

Five princes proposed to her, and to each she gave an impossible task. The first was told to bring her the stone begging bowl of the Buddha Shakyamuni from India; the second, a jeweled branch from the mythical island of Hōrai; the third, the legendary robe of the fire-rat of China; the fourth, a colored jewel from a dragon's neck; and the final prince, a cowrie shell born of swallows. All five princes failed, and Kaguya remained unwed. Then the Emperor of Japan proposed to her, and she denied even him.

That summer, Kaguya grew restless and anxious, visibly conflicted about some problem. Finally, like a clear lotus blossoming from murky waters, she confessed to her adopted parents that she was actually a princess from the Moon. She had been sent to Earth to remain protected while a celestial war wracked the heavens. But the war was over, and her heavenly family was coming to collect her. She was given the choice to stay with the woodcutter or return to the Moon and forget her life on Earth. It was a difficult decision with no clear answer.

Soon the celestial entourage came for Princess Kaguya, and she chose to go with them. With tears in her eyes, she said good-bye to her foster parents. When her heavenly robes were placed on her shoulders, her tears disappeared. She forgot her parents and all her time on Earth and returned to the Moon.

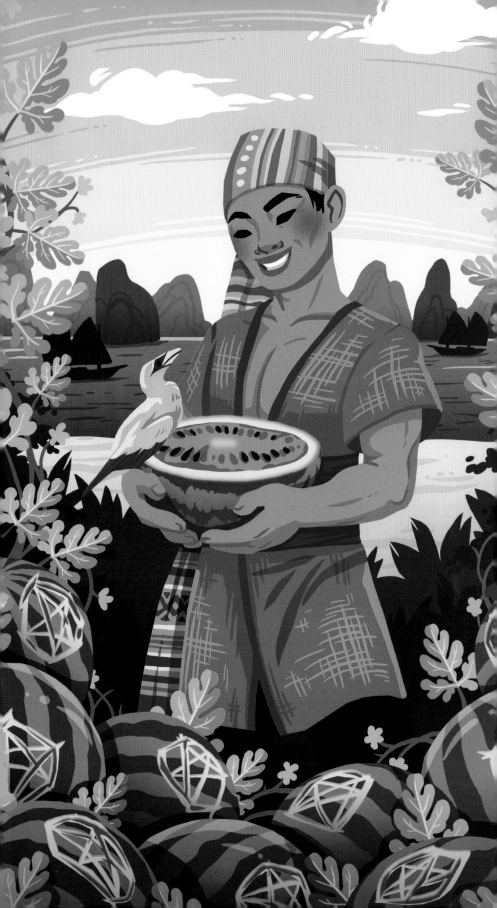

The Legend of the Watermelon

VIETNAM, VIETNAMESE LEGEND

A long time ago, an orphan boy ended up in service to the king of Vietnam. The king named him Mai An Tiem, and he grew up to be so charming, intelligent, and skillful that the king offered his own daughter in marriage. The king gifted the young Mai An Tiem a large house and many servants. When the princess gave birth to three children, the king gave them even more gifts, and the young family lived happily in wealth and comfort.

But the king's favor for Mai An Tiem made others jealous. At one banquet, a courtier commented on Mai An Tiem's good fortune, to which Mai An Tiem responded that all his good luck must be his own reward for living a good life. The sly courtier told the king that Mai An Tiem was ungrateful and did not respect the king and his generosity for elevating Mai An Tiem.

The king grew angry and banished Mai An Tiem and his small family to a desolate island. The family struggled to survive in the sand with little fresh water. Mai An Tiem was searching for more water when he saw a strange yellow bird pecking at something on the ground. Closer inspection revealed a juicy fruit with an interior as red as blood and full of seeds. Mai An Tiem ate a small bit and loved the sweet taste; it relieved his hunger and his thirst. He shared the rest with his family, and together they tilled the land and planted the seeds.

They soon had more of the fruit, which he called dưa hấu, or watermelon, than they could ever need, and Mai An Tiem began carving his name on the outside of the melons and setting them adrift in the sea. A merchant saw and ate them and came back to the family to trade for more. They started a watermelon business. It grew so large they needed a large house and many employees, and they became very wealthy once again.

By this time the king heard of Mai An Tiem's watermelons and realized that it was Tiem's resourcefulness and not the king's favors that had brought his good fortune. The king begged Mai An Tiem's forgiveness, which was granted, and the family was happily reunited with the king.

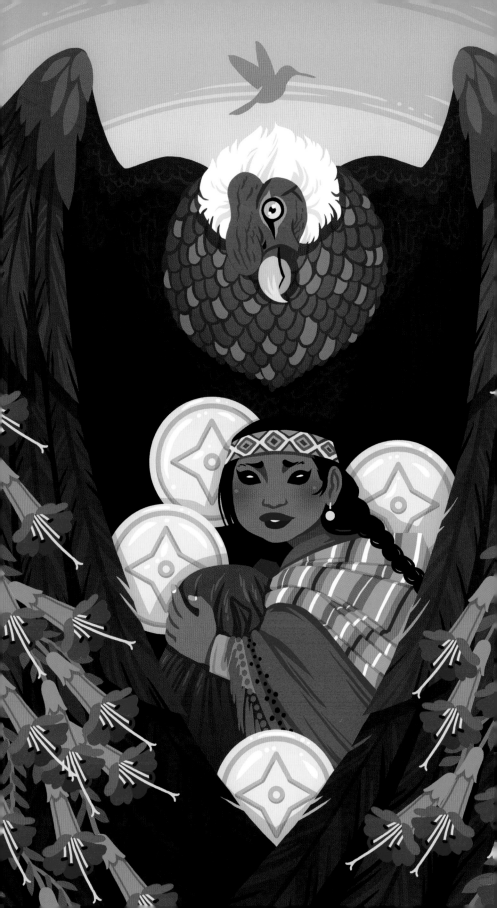

Condor's Wife

PERU, AYMARA FOLKTALE

One day near the beginning of the world, Condor was flying near Lake Titicaca when he spotted a beautiful young girl tending to her family's llamas and picking berries. He landed next to her and began conversing with her, helping her pick berries. She was so sweet he began to fall in love, and he invited her to come live with him. The girl was flattered, but she said that she couldn't leave her poor mother alone, and someone had to tend the llamas. Condor was saddened but said he understood. He asked if she could just do one small favor for him and scratch his shoulder in a very hard-to-reach spot. So the girl leaned over to do just that and, before she knew what was happening, was whisked up into the air on Condor's back.

He flew her far away to his home high up in the sky. There he introduced her to his extended family. All his family members were very nice to the girl, and his mother especially took pains to make sure the girl was cared for. But though they were kind, they fed her vulture food, which is rotting meat. The girl cried and cried, distressing Condor, who only wanted his bride to be happy. Her cries were heard by Hummingbird, who realized what had happened.

The clever Hummingbird approached Condor and told him that his young bride only wanted to eat cooked meat, and he had seen a delicious roasted alpaca in a village on the other side of the mountain. Condor leapt at the opportunity and flew off to retrieve some food his wife would enjoy. Hummingbird took this opportunity to help the girl climb down from Condor's nest and escape back home, where her worried mother was relieved to see her again.

Condor, for his part, was frustrated when he returned and realized the girl had escaped. He quickly found Hummingbird and tore him into a thousand pieces. But instead of dying, each piece turned into a new hummingbird, and that is why there are so many kinds of hummingbirds in the world.

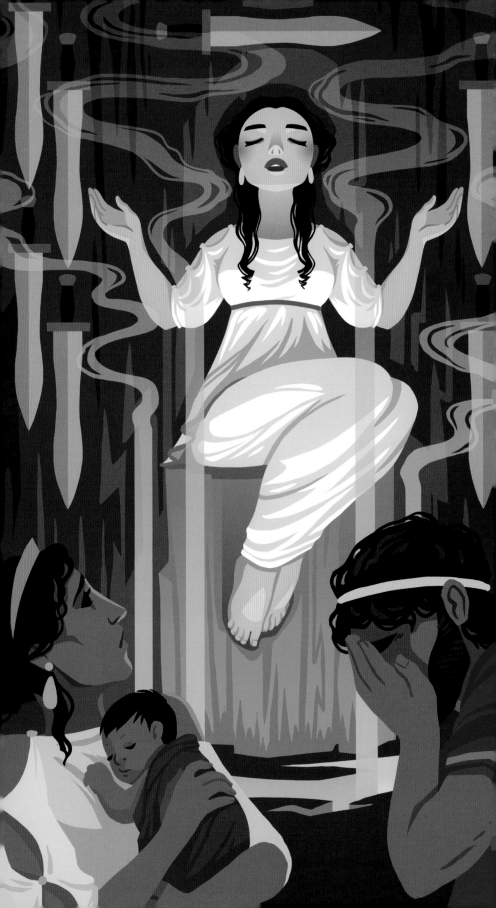

Oedipus and the Oracle at Delphi

King Laius and Queen Jocasta ruled over Thebes but had long been childless. Finally, Jocasta became pregnant, and the royals consulted the Oracle of Apollo at Delphi about their child. Devastatingly, the oracle prophesied that the son of Laius would kill him. In an attempt to avoid this, Laius commanded the baby be abandoned to die on a mountaintop with his ankles tethered so he could not crawl away. The servant tasked with abandoning the child took pity on him and gave him to a shepherd, who passed him to the childless King Polybus and Queen Merope of Corinth, who named him Oedipus.

Oedipus grew up as a prince, and once he was an adult, he consulted the Oracle at Delphi. The oracle told him he was destined to murder his father and wed his mother. A mortified Oedipus, who never knew he had been adopted, opted to avoid his fate by never returning home to Corinth. Instead he chose to travel to Thebes and make his fortune there. Along the way, he came to a crossroads and got into an argument with a belligerent man. Oedipus killed the man, not knowing that this man was King Laius nor that he was his father.

Before reaching Thebes, Oedipus encountered a deadly Sphinx who demanded an answer to her riddle. Oedipus was able to solve it, and she allowed him to pass. Word of this confrontation traveled fast, and Queen Jocasta's brother, Creon, announced that any man who could defeat the Sphinx was worthy to marry the newly widowed Jocasta and to become the new king of Thebes. So Oedipus and Jocasta married and had four children together. Many years later a plague struck Thebes, and they learned from the Oracle at Delphi that the only way to cure the plague was to have King Laius's murderer brought to justice.

Oedipus promised swift and brutal vengeance, but as he sought the murderer, he realized that he was the one who killed Laius. And Jocasta and he both realized that she was his mother. In anguish, Oedipus stabbed his own eyes out and exiled himself to wander as a blind man forever.

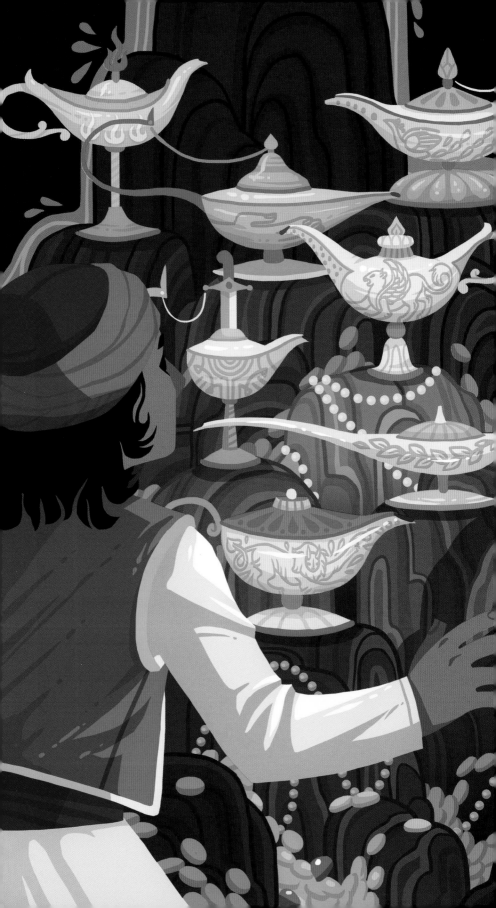

Aladdin

PERSIA, ARABIC FOLKTALE

There once was a young man named Aladdin who was very poor and very lazy. While shirking work one day, he met a mysterious-looking sorcerer who claimed to be Aladdin's dead father's long-lost brother. Aladdin didn't believe him, but when the man gave Aladdin money as a sign of goodwill, Aladdin was willing to believe anything. So Aladdin agreed to follow his "uncle" on a trip out of town. When they reached a certain spot, the sorcerer said some magic words, and a pit in the ground opened up. The sorcerer gave Aladdin a magic ring to guide him and told him to retrieve a lamp from the pit but to not touch anything else or he would die. Aladdin reluctantly agreed to this after the sorcerer beat him; when he found the lamp, drawn to it by the ring, Aladdin refused to hand it over.

Furious with his refusal, the sorcerer sealed Aladdin inside the pit, leaving him to die.

Aladdin then discovered that both the ring and the lamp held unlimited-wish-granting genies, and he used them to return home and set himself up lavishly. He purchased expensive gifts and used them to ask for the Sultan's daughter's hand in marriage. The Sultan was impressed with these gifts and eventually overrode his Grand Vizier's reluctance of Aladdin. The princess was then free to marry Aladdin.

The two were wed, and Aladdin used magic to construct a beautiful palace where he and his princess lived happily. But all this magic alerted the sorcerer, who by this time realized Aladdin had escaped the pit. So the sorcerer used his wiles to trick the princess into throwing out the lamp, which he retrieved and then used to make the palace, the princess, and himself vanish. Aladdin, finding his home gone, used his ring genie to transport himself to his missing palace. There, he convinced his wife to seduce the sorcerer in order to steal back the lamp. She did so, and together they killed the sorcerer and returned everything to its rightful place.

Fenrir

In Asgard, the shapeshifter and trickster Loki, who was an Æsir, or Norse god, had three children by Angrboda, a female jötunn, or troll. These children were the gigantic snake Jormungandr, the ghoulish-looking woman Hel, and the terrifying wolf Fenrir. The ruling gods of Asgard soon discovered these children and feared them not only for their own terrible power but also for their troll mother and, worse still, their trickster father. The gods prophesied that they would cause much mischief and destruction.

Odin, the leader of the gods, brought the three children before him. He cast Jormungandr into the sea and sent Hel to rule the cold wasteland called Niflheim. But Odin knew Fenrir would need to be dealt with differently. The prophecies had foretold that Fenrir would overthrow Odin and cause Ragnarok, or the end of the world. The gods kept Fenrir close, but each day he ate more and grew bigger and bigger until they worried they could no longer constrain him. The gods devised a plan to trap the wolf. They approached him with a fetter, saying they wished to test his strength. Fenrir had no fear, and as soon as the fetter was on him, he snapped it off with a mighty kick.

Hiding their fear, the gods brought forth a second, even stronger fetter. Fenrir agreed to test it and himself, wanting the fame of his strength to spread. He fought and strained against the second fetter until it, too, broke.

With this the gods asked the dwarfs to make a magical fetter, which they called Gleipnir. Gleipnir was as thin as a ribbon, so Fenrir was dubious. He said he would try it on only if he was promised release and if a god placed a hand in his mouth. Only the god Tyr was brave enough. When Gleipnir was wrapped around him, Fenrir kicked and struggled but was unable to free himself. In his rage, he bit off Tyr's hand, and the gods, in revenge, stuck a sword in his mouth to keep it pried open. They then tied him to a giant rock, and to this day he waits to be freed and cause Ragnarok.

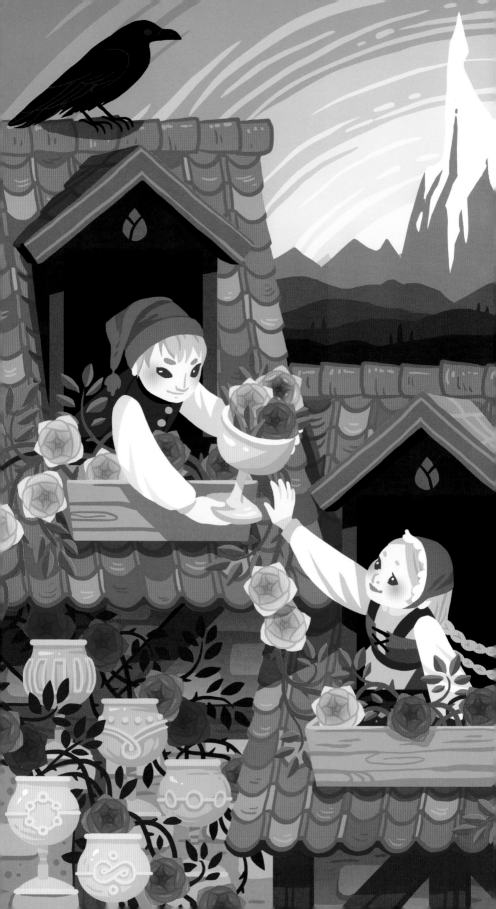

The Snow Queen

DENMARK, DANISH FAIRY TALE

Once upon a time, there were two children, Greta and Kai, who were the very best of friends. They lived next to each other and grew roses and vegetables in the window boxes between their houses. They shared everything.

One day the Devil's mirror shattered, and tiny pieces flew across the earth. One piece landed in Kai's eye, and everything he saw became vile. One piece landed in his heart, and he became cruel. He smashed the flower boxes he shared with Greta. When the Snow Queen arrived that winter, she was attracted by his beauty and his cruelty, and he left with her. The Queen kissed him twice, once to make him immune to the cold and once to cause him to forget Greta.

When Greta realized Kai was gone, she went on a journey to find him. She asked an old woman for directions but was trapped in her garden until the roses helped set her free. Next, she met a crow who thought he had seen Kai, but it was just a clever prince who had married a very wise princess. Greta was then captured by a band of robbers but was set free by their violent female leader, who took a liking to her. Finally, she rode on the back of a reindeer all the way to the north, where a Sami woman told her that her own purity of heart was all she needed to defeat the Snow Queen.

Greta journeyed to the Snow Queen's castle, which was made of ice and surrounded by snowflakes. Inside she found Kai alone on a frozen lake next to the Snow Queen's throne. Greta hugged Kai's cold body and began to cry. Her tears melted the mirror shard in Kai's heart, and as emotion filled him again, he began to cry as well. His tears melted the mirror shard in his eye, and he could see things as they were once again. He remembered Greta, and the two danced and rejoiced. Then hand in hand they began the long journey home with the aid of the reindeer, the Sami woman, and the robber girl.

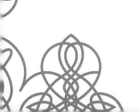

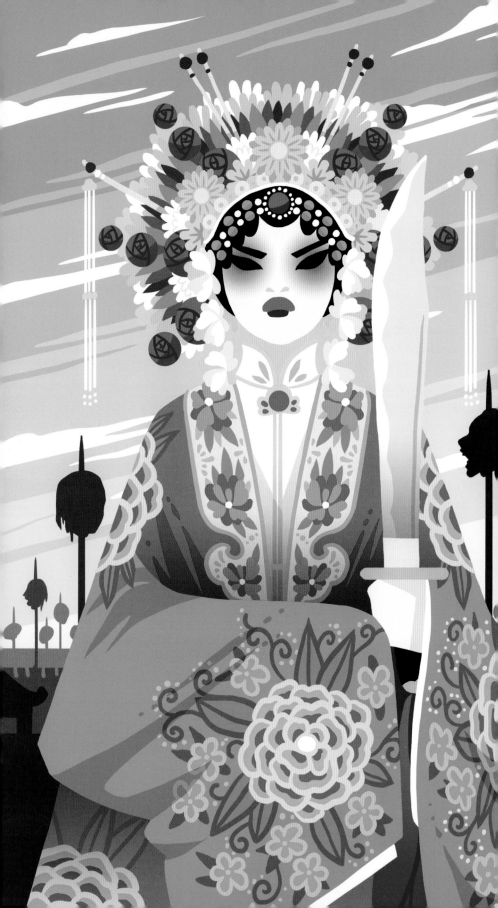

Turandot

CHINA, ARABIC FOLKTALE

There once was a princess named Turandot who was so beautiful that men constantly fell in love with her and proposed. But Turandot hated all men. She remembered her past life as a princess who was abused at the hands of an invading prince, and so Turandot swore to never marry. Still, men pursued her in droves, so she devised a challenge. Men who wished to propose to her had to answer three riddles. If they failed, they would be beheaded.

Into this kingdom came the young prince of Tartary; his father, the deposed king of Tartary; and their lone servant, the young girl Liu. They arrived just in time to see the prince of Persia fail the three riddles and die before the cold Princess Turandot. The prince of Tartary instantly fell in love with Princess Turandot and proposed to her right then and there. Liu, who was secretly in love with the prince, begged him to not attempt the riddles.

Turandot's father, the emperor, was tired of his daughter's trials and urged the prince to give up on the riddles. Turandot herself warned the prince, telling him to avoid the riddles. The prince paid them all no heed and proceeded to correctly answer all three riddles.

Surprised at his success, Turandot was trapped. She cried and begged her father to help her break her oath to marry the prince. The emperor told her she was bound to keep her word. The prince, moved by Turandot's tears, offered his own challenge. If she could find out his name by dawn, she could kill him.

So Turandot sent out her ministers to discover the prince's name, but no one knew it. Finally, they brought forward the servant Liu and demanded that she tell them the prince's name. When she refused, they began to torture her. Still she refused to speak, only calling the prince "Love." Finally, she fell on her own knife and died in the prince's arms. The prince, moved by Liu's compassion, rebuked Turandot for her cruelty.

Princess Turandot, in a riot of confused emotions of love and hate, asked the prince to leave. Instead he told her his name, Prince Calaf, son of Timur. As dawn rose, the emperor asked Princess Turandot for the prince's name. She called him Love, and they were soon wed.

Waramurungundju

NORTHERN AUSTRALIA, GUNWINGGU DEITY

In the beginning, the world was very empty and dry. Then Rainbow Serpent came and brought the wet season of rain and floods. The giant snake used its powerful body to slither across the earth and form rivers and gullies. It created thunderstorms and lightning, and it lived in waterholes that never dried up. Then Rainbow Serpent led the goddess Waramurungundju from across the sea.

Upon arriving on land, Waramurungundju, which was only one of her many names, gave birth to the first people. She had many children, and to each of them she assigned a place to live and a language to speak. This is why there are so many different peoples who speak so many different languages on the earth, all with the same mother. Waramurungundju began to travel across the land, giving birth to more children. Sometimes she was accompanied by Rainbow Serpent, who became associated with menstruation, coming-of-age ceremonies, and fertility. But the serpent left her side, for some places needed the rains to end. Sometimes she was accompanied by the man Wuragg, who traveled by her side. But Wuragg eventually left her for his own journeys and wives before turning into a mountain.

Waramurungundju continued on alone, and she gave birth to animals and plants and put everything in its place. In one spot she created bees that produced sweet wild honey; in another spot she created the banyan tree. She even carved and created many natural features of the landscape. In this way she was responsible for much of the countryside, and her many children prospered.

Eventually she reached the end of the land and disappeared. Some people think she returned to the sea, while others think she's still somewhere on the earth, but no one knows for sure.

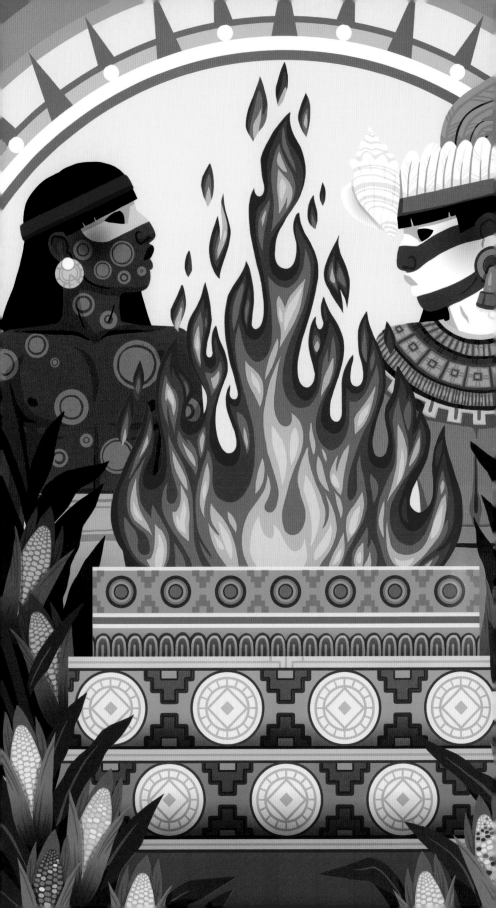

Nanahuatzin

In the beginning it was very dark, so the gods decided that someone needed to become the sun to light up the world. The first sun was Tezcatlipoca, but his light was weak. So the other gods knocked him down. Then Quetzalcoatl became the sun, but he became upset and destroyed the world in a hurricane. The third sun was Tlaloc, but his wife was seduced by another god, and he became so angry that he destroyed the world in fire. The fourth sun was Chalchiuhtlicue, but she was mistreated and so she cried blood and destroyed the world in a flood.

When it came time to choose the fifth sun, the gods decided the only way to make a sun strong enough was for someone to sacrifice their own life in fire. They chose the beautiful, wealthy, and strong Tecciztecatl to become the sun. They chose the ill, poor, and weak Nanahuatzin to become the moon. The proud Tecciztecatl saw the sacrifice as a way to boost his own notoriety, and he made offerings of coral and other expensive gifts. The humble Nanahuatzin saw the sacrifice as his duty, so he made offerings of his own blood and performed acts of penance.

The gods created a large bonfire and a high platform for the two deities to jump from into the flames. They summoned Tecciztecatl and Nanahuatzin to the top and then bid Tecciztecatl to immolate himself. But at the last moment, Tecciztecatl grew frightened. He tried and tried to make the leap, but his courage deserted him and he cowered away. So Nanahuatzin calmly stepped up and threw himself into the fire. Embarrassed to be upstaged by the ugly Nanahuatzin, Tecciztecatl jumped in behind him. Shortly after, two suns were seen flying into the sky.

Disgusted with Tecciztecatl's show of fear, one of the gods took a rabbit and threw it in Tecciztecatl's face. Tecciztecatl's face dimmed and so he became the moon. Nanahuatzin, for his part, flew up high and glowed with such strength and brilliance that the world began to parch and burn. So the gods created the winds to move the sun through the sky and create night and day.

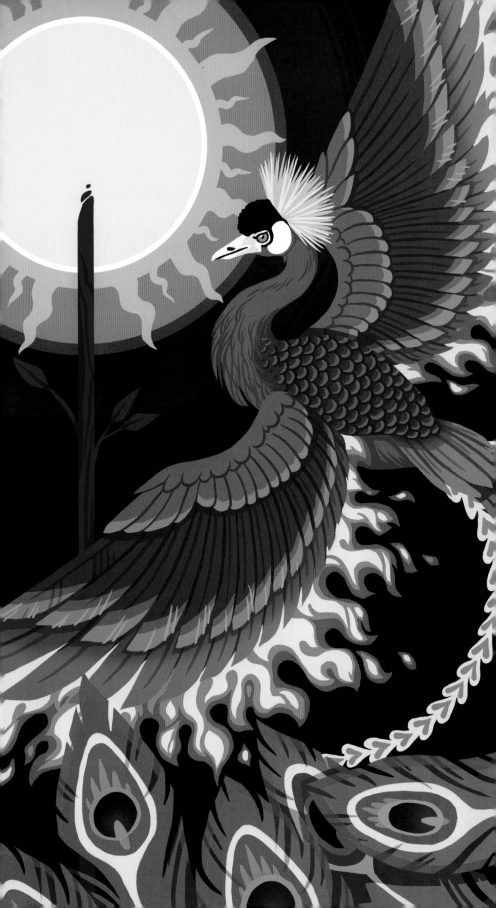

The Phoenix

EAST ASIA, EAST ASIAN MYTHOLOGY

The phoenix is a magical fire bird associated with ideas of strength, power, destruction, and rebirth. The story of the phoenix exists across many different cultures and with many different names, but it is always a bird of fire and good fortune.

One of the most well-known stories of the phoenix comes from Greece. There the bird is nearly invincible, flying between the earth and heaven, the mortal and the divine. Every thousand years it begins to age and die. That is when it builds a nest made of myrrh and cinnamon and immolates itself. From the ashes an egg is formed that hatches a newly reborn phoenix.

There are many Slavic stories of the fire bird and its beautiful glowing plumage. Its long tail feathers are coveted by many kings and heroes, including Ivan Tsarevich and the evil sorcerer Kaschei the Immortal. The feathers glow with power even after they are dropped by the bird and can bring great fortune—as well as great destruction—to whomever possesses them. As the bird flies across the world, pearls drop from its beak for the poor and less fortunate.

In Japan, the phoenix is called Ho-ho. It is a sun bird that descends from its home in the heavens to bless the births of virtuous rulers and mark the beginning of a new era. It flies through the skies, a symbol of goodwill from the heavens. It can be found perching on top of torii, the gateways to sacred religious Shinto shrines or the passageways between the mortal and the divine worlds. The mythical bird heralds a time of peace and balance, and its disappearance back to heaven harkens a time of disharmony and destruction.

Zhu Que, the Vermillion Bird, is the name of the phoenix in China. It is one of the four constellations making up the four cardinal directions. It is the fire bird of the south and is associated with the summer season.

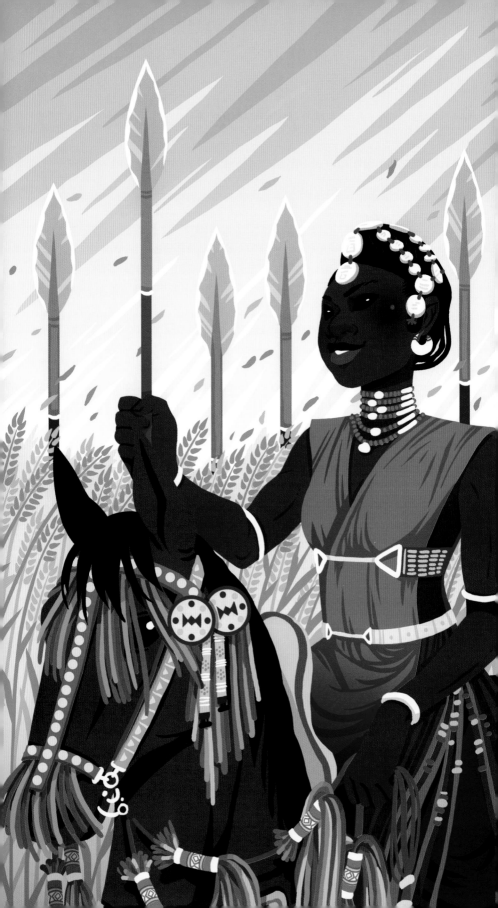

Yennenga

There once was a strong and beautiful princess named Yennenga. She was the daughter of Nedega, the king of Dagomba, and her battle prowess was known far and wide. She was skilled with the javelin, spear, and bow and was an unparalleled horsewoman. She commanded her own battalion, and at only fourteen fought for her father in a battle against the neighboring Malinke. Her skill was so great that she became very precious to her people, and her father feared losing her. When she was of marriageable age, he refused to let her wed even though she desired a husband.

Irritated with her father, Yennenga planted a field of wheat and helped it grow tall and lush. When it came time to harvest the wheat, she left the grain to rot in the field untouched. In this way, Yennenga expressed to the king her displeasure at not being allowed to choose a husband for herself. But the king was unmoved by her gesture. Instead he locked her up, in a further attempt to keep her from marrying.

Aided by a friend, Yennenga, dressed as a man, escaped from her father and rode away atop her stallion to the north. She narrowly escaped capture by the Malinke, finally finding refuge in a forest. There she met elephant-hunter Riale, who saw through her disguise. Soon the two fell in love and had a son they named Ouedraogo, which means "stallion," after Yennenga's horse.

King Nedega did not give up the search for his daughter. After many years, he finally learned where she was and that she was still alive. He sent a delegation to her requesting that she come back home, and he even threw a giant feast in her honor. Yennenga agreed and, along with Riale and Ouedraogo, was warmly welcomed back to her kingdom. King Nedega oversaw his grandson's training and gave him cavalry, cattle, and goods, which Ouedraogo took north to form his own kingdom, Tenkodogo, which eventually became the heart of the Mossi kingdoms.

In this way, Ouedraogo founded the Mossi kingdoms, and Yennenga is the mother of the Mossi people of Burkina Faso.

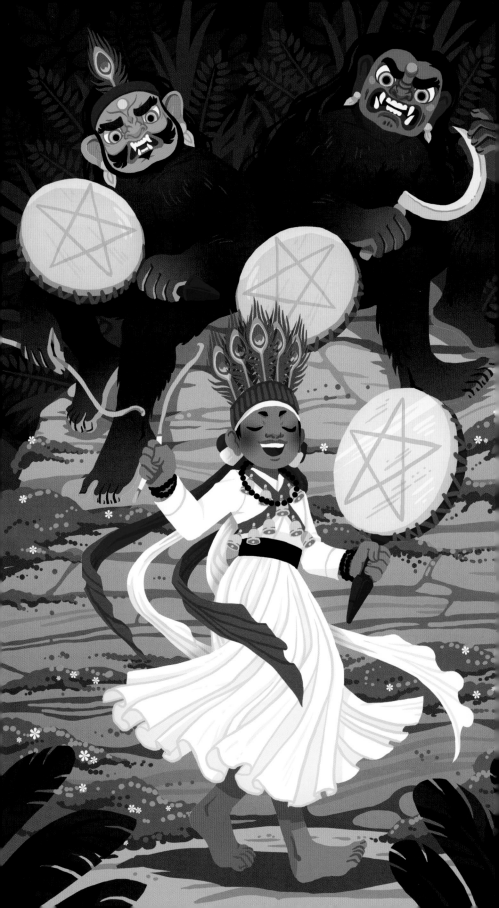

Banjhakri and Banjhakrini

NEPAL, TAMANG MYTHOLOGY

In the mountains of Nepal, there are stories of the Banjhakri and his terrifying wife, the Banjhakrini. The Banjhakri was similar to the apelike yeti but was smaller and much more intelligent. He was born from the sun to protect the forest, and his flesh and bones could cure many ailments and heal many wounds. First and foremost, he was a shaman, and many stories tell of how he trained new shamans.

The Banjhakri was always on the lookout for new initiates to become great shamans, but he was very particular in his choices. They had to be children, and they couldn't have any scars or imperfections on their bodies. If he approved of them, he kidnapped them, took them to his cave, and put them through rigorous training and tests. Some children reported being forced to eat worms with the backs of their hands, or having their hands dipped in hot oil, or being forced to perform difficult physical tasks. Children unable to keep up were left to the mercy of the bloodthirsty Banjhakrini and her golden sickle. Some of those children returned home beaten and bruised, and some never returned at all. But children who were able to remain steadfast and strong through the testing were rewarded. Years later they returned to their homes as fully trained *jhakri*, or shamans. They could now play the sacred dhyangro drum, commune with the spirit world, and cure diseases. Jhakri performed rituals at harvests, weddings, and funerals, singing and dancing and beating on their dhyangro drums. They also performed voluntary spirit possession, where the spirits of dead family members could possess the jhakri to communicate with their living family members for a short time.

Though these children-turned-jhakri could pass on their knowledge to their disciples, no one trained by a human could be as powerful as one trained by the Banjhakri himself.

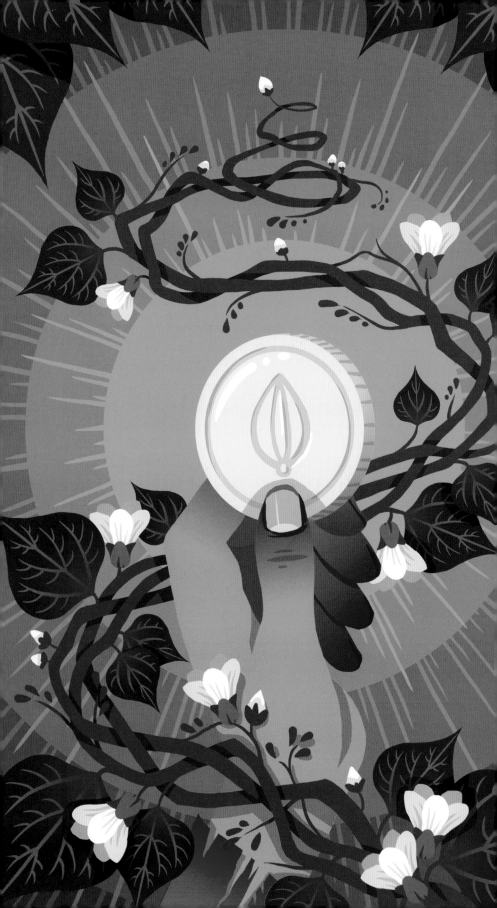

Jack and the Beanstalk

ENGLAND, ENGLISH FAIRY TALE

There once was a poor young boy named Jack who lived with his mother and their one and only milking cow. There came a day when the cow became too old, and she stopped giving milk. Because she was the impoverished family's only source of income, there was nothing for them to do but sell her. So Jack reluctantly took the cow to the market. On the way into town, Jack met a bean seller, who offered to buy the cow for a single magic bean.

Convinced that a magic bean was worth a lot and being too lazy to go all the way into town, Jack agreed to the deal and returned home. His mother, however, was furious. In a rage, she threw the bean out the window and spent the night sobbing. In the morning, the small family realized the bean had grown into a giant beanstalk, reaching up into the sky and piercing through the clouds. A curious Jack decided to climb up the stalk. At the top, Jack found a huge castle belonging to a giant. He slipped in and, with the help of a friendly giantess, managed to avoid being detected by a rather bloodthirsty giant.

When the giant fell asleep, Jack stole a bag of gold coins, a goose that laid golden eggs, and a harp that talked and played itself. Unfortunately, the harp did not want to be stolen, and it shouted out to the giant, waking him up. The giant roared when he realized what was happening and chased Jack down his beanstalk. Jack quickly scrambled down the stalk, just managing to reach the bottom as the giant started his own descent. The young boy grabbed an ax and quickly chopped through the beanstalk. The beanstalk toppled, and the giant fell to his death.

From that day on, Jack and his mother lived comfortably off the gold coins and golden eggs and were serenaded by the beautiful sounds of the magical harp.

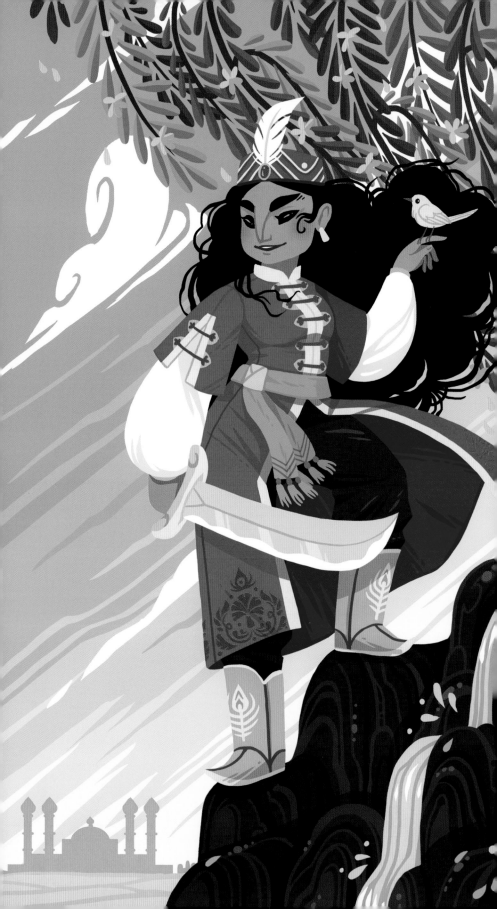

Princess Parizade

ANATOLIA, ARABIC FOLKTALE

Sultan Kosrouschah was once traveling through his city in disguise when he overheard three poor sisters talking about their dream husbands. The oldest said she wished to marry the royal baker and eat bread all day. The next said she wished to marry the royal cook and eat rich food all day. The youngest, who was the most beautiful, said she wished to marry the sultan and give him children. The hidden sultan was amused, and the next day he granted all three sisters their wishes. The older two became jealous of their younger sister. So when she gave birth to a baby boy, another boy, and a daughter, they stole each child and set him or her adrift in the river. They told the sultan that she had given birth to a dog, a cat, and a stick. The sultan became livid and imprisoned his wife in a tall tower.

The three children were all found and adopted by the royal gardener, and he named them Bahman, Perviz, and Parizade. They lived happily together until the old gardener died, never telling the siblings about their true parentage. The siblings grieved till one day Parizade was kind to an old woman who told her about three magical objects: the talking bird, the singing tree, and the golden waters. Parizade was determined to set out and find them. But her brothers wouldn't permit her to leave and instead set out themselves to retrieve the items for her. Bahman and Perviz found a dervish who told them to climb a particular mountain and never look back no matter what they heard. But they were unable to ignore the taunts they heard on their climb. They looked back and were turned to stone. Parizade eventually followed after. But at the mountain she stuffed her ears with wax and laughed at the voices who tried to taunt her. At the top she found the magical objects. With the golden water, she cured her brothers; with the singing tree, she brought magic to her garden; and with the advice of the talking bird, she convinced the sultan that she and her brothers were his legitimate children. Their mother was freed, and they became part of the royal family.

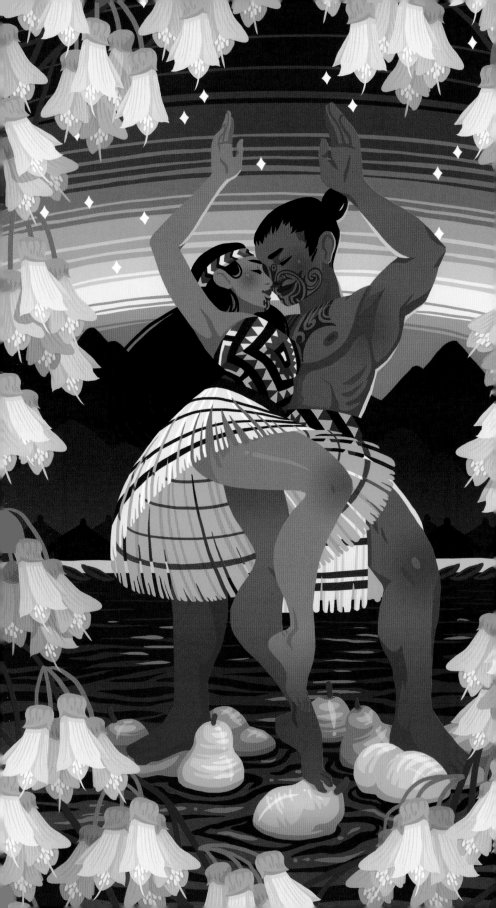

The Legend of Hinemoa and Tutanekai

NEW ZEALAND, MAORI LEGEND

A long time ago, there was a great chief who lived at Owhata on the shore of Lake Rotorua in New Zealand. He had a beautiful daughter named Hinemoa, whom many young men wished to marry but she had eyes only for the handsome Tutanekai. Tutanekai was also enamored of Hinemoa, but he knew that though he was of good birth, his rank was too low for Hinemoa's father to ever accept him as a suitor. He was not even a *tohunga,* or skilled practitioner, of magic, someone able to make the Kōwhai flowers spontaneously bloom to win himself the admiration of his lover. So he watched her from afar, and because he lived far out in the middle of the lake on Mokoia Island, he saw her very infrequently. Finally, Tutanekai confessed his feelings to Hinemoa, and she to him, and they agreed to be married despite the chief's disfavor. They agreed the best thing to do would be for Hinemoa to steal a canoe in the dead of night and row to Tutanekai. Tutanekai, for his part, would play his flute to guide her and let her know the coast was clear.

For several nights Tutanekai played his flute, but Hinemoa never came. The chief had suspected Hinemoa's intentions and ordered the canoes to be pulled up far out of the water each night. Growing desperate, Hinemoa finally came up with an idea: she would tie hollow gourds to her clothing to keep her afloat and swim across the lake.

Hinemoa swam through the night, resting on the floating gourds when she grew tired, following the sound of Tutanekai's flute when she lost her way. Exhausted, she finally made it to shore and revived herself in a warm pool of water. She teased and lured Tutanekai to her side, and they were married right away.

The next morning, everyone discovered Hinemoa and Tutanekai had been married. The chief accepted and blessed the couple, and the pair lived happily ever after.

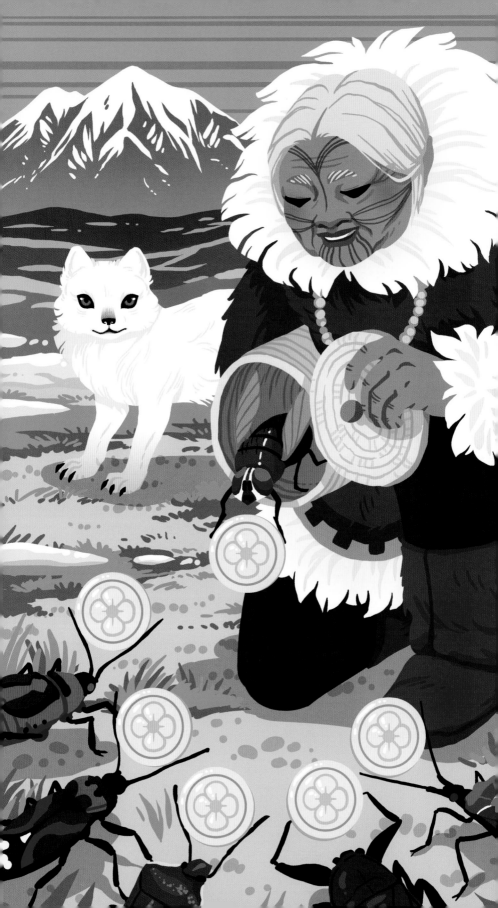

The Woman Who Was Kind to Insects

ALASKA, INUIT FABLE

One year as winter approached, an old woman was left behind in her tribe's summer campground. She had few teeth left to eat with, she could no longer make leather goods to sell, and she moved too slowly to make the journey to the new hunting ground. As the rest of her people moved on, they left behind a few insects in a basket for her to eat.

The old woman looked at the insects and thought to herself that the poor insects were still very young and she was very old. She thought that she did not have much time left to live, but these insects still had their whole lives in front of them, and maybe they would even have children as she had done. And so she decided to not eat them but to set them free.

The insects all flew or crawled or skittered away from the old woman, but they did not forget her. Soon they sent a small fox to the old woman's camp. After sniffing her a few times, the fox jumped on her and began to bite her in a strange manner. Though the old woman initially thought her death had arrived, she realized that the fox was biting just at the edges of her skin, almost creating seams around the length of her body. The fox nipped and bit away until the old woman was able to shuck off her skin like a coat. Stepping out of her old skin, she saw the skin underneath was fresh and soft, like that of a much younger woman. She ran to the water and saw in her reflection that she had become young again.

The insects she had freed now gathered around her and thanked her for letting them live. She thanked them for giving her new life. And so she followed them back to their home and, it is said, married a blowfly who was very kind to her.

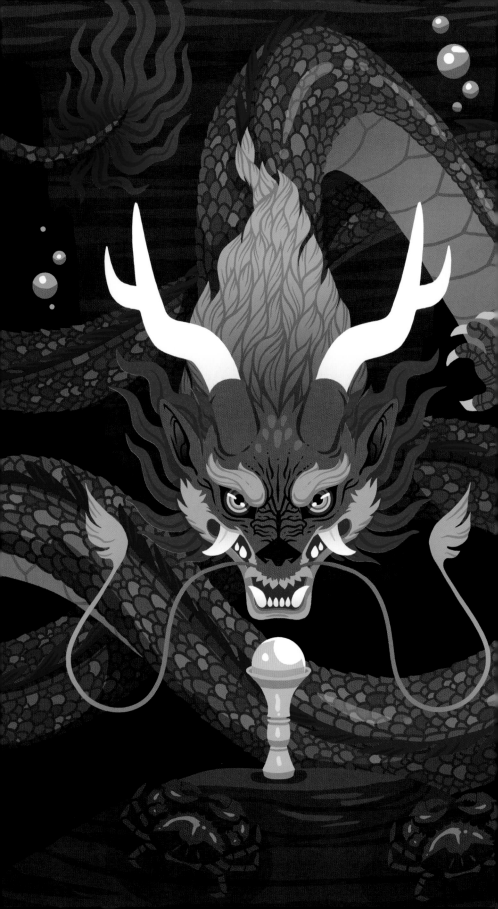

The Boy and the Dragon Pearl

CHINA, CHINESE LEGEND

Dragons in China are very powerful. They are symbols of strength, mystery, and good fortune. They can make themselves as small as silkworms or as large as the universe. They can live in heaven or deep in the ocean and control typhoons, tidal waves, floods, and rain. They can travel far distances, and some have even been known to favor men in mountain retreats. They are often known to carry a pearl that contains much of their magical power. Dragons are so magnificent, there is even an expression in Chinese that means "to hope one's son will become a dragon."

There once was a little boy who lived in a small village that was starving from years of drought. Nothing would grow, and even the wild animals were suffering. When the boy saw a fat rabbit, he followed it to its home. There he found a small patch of greenery that was flourishing, which, when he dug it up, was growing around a giant pearl. Thinking he could sell the pearl for food, the little boy and his mother put it in a rice jar that night and slept peacefully. In the morning, they found the once-empty rice jar overflowing. The same miracle repeated itself again with the rice jar, an oil jar, and then with a box of money. The boy and his mother realized the pearl was magic and were able to stop worrying about food. But their newfound luck was noticed by greedy men who smashed the boy's house in order to find whatever they had.

The little boy grew terrified, and in his fear swallowed the pearl whole. He began to feel unbelievably thirsty. He drank a whole jug of water, then a whole well, then he plunged himself into the river. He emerged as a giant dragon, swishing his tail back and forth, and frightened the men away. The boy-turned-dragon looked at his mother and she at him, and they knew he could never be changed back. So instead he became the protector of the river, and his mother visited him often.

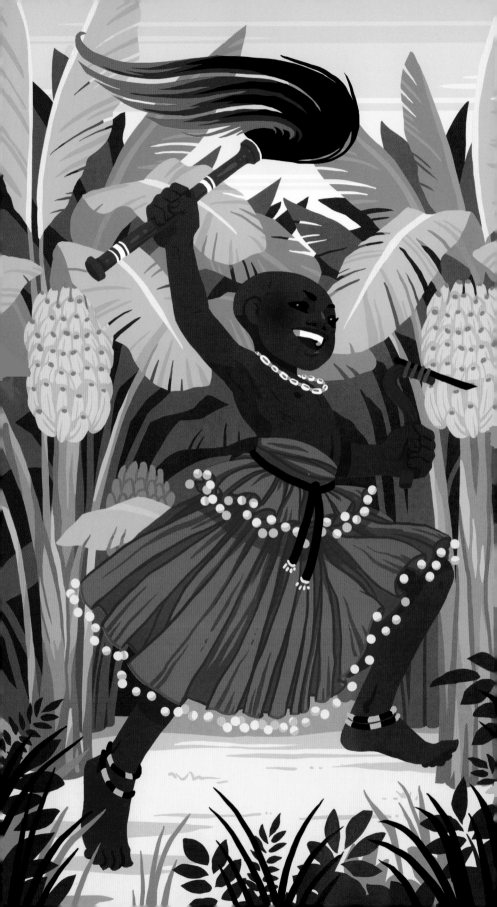

Mwindo

DEMOCRATIC REPUBLIC OF THE CONGO,
NYANGA MYTHOLOGY

A long time ago in the village of Tubondo, the evil chief Shemwindo threatened his wives to give birth only to daughters. His first six wives gave birth to baby girls, but the seventh wife, Nyamwindo, gave birth to a son from the tip of her middle finger. The boy was named Mwindo, and he was born with a magical flyswatter, an adze-axe, and a bag of fortune with a long rope inside. Shemwindo soon found out about his son and sought to kill him by sealing him in a drum and throwing him in the river.

The drum easily floated, and Mwindo decided to take the opportunity to visit his aunt Iyangura. His journey was met with many obstacles, including gods who barred his way, but he also met gods who decided to help him. He eventually earned the allegiance of his aunt, and she helped him enlist his uncles to forge a magical suit of armor so that he could return to Tubondo to challenge his father. A great battle ensued, ending only when Mwindo summoned lightning from the god Nkuba to destroy Tubondo. Mwindo resurrected the village with his flyswatter, only to realize Shemwindo had escaped down a secret hole that was a portal to the underworld.

Mwindo chased his father to the doorstep of Muisa, God of the Dead, and Muisa's daughter, Kahindo. Mwindo befriended Kahindo, and she helped him defeat her father's many tricks, including growing and harvesting a banana plantation in one night. But by the time Mwindo defeated Muisa, Shemwindo had already escaped out of the underworld and up into the sky. Mwindo followed him and gambled with the Sky God, Sheburungu, for possession of his father. Mwindo eventually won and took his father back to Earth.

Once back in Tubondo, Mwindo rebuilt the city and married a human woman. He had three brass thrones built, which floated ten feet off the ground. His aunt sat on the right, a strong adviser; his father sat on the left, a silent prisoner; and Mwindo sat in the middle, a wise and powerful king.

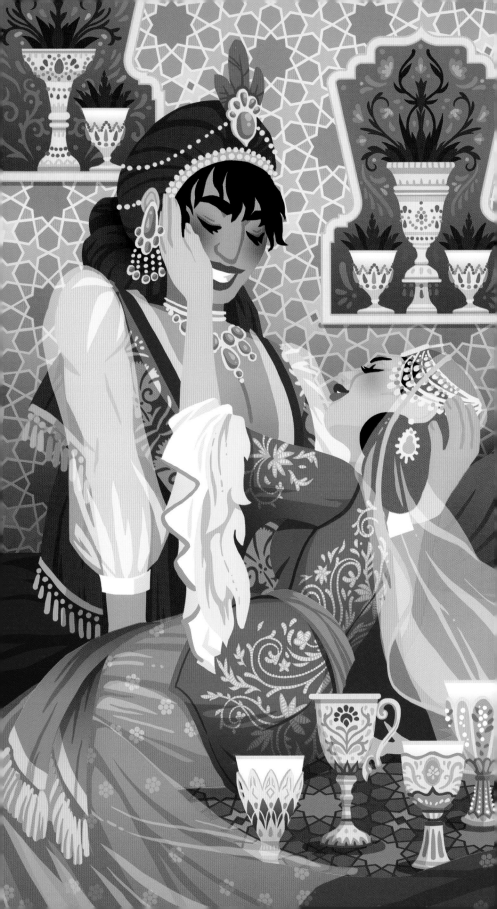

Tale of Tàj al-Mulúk and the Princess Dunyà

IRAN, ARABIC FOLKTALE

Prince Tàj al-Mulúk, son of King Sulayman, Shah of the Green Land and the Mountains of Isfahan, was eighteen when he met Aziz, a merchant from a distant land. Aziz showed Tàj al-Mulúk his many wares, but most stunning of all was a piece of linen depicting graceful prancing gazelles. He went on to tell the prince that the work was created by the hands of the beautiful and clever Princess Dunyà of the Camphor Islands. Without having met her, Tàj al-Mulúk became infatuated with the princess, so he had his father send a delegation to her to ask for her hand in marriage. However, Princess Dunyà told them she hated men and threatened to kill any husband she was forced to marry.

Undeterred, Tàj al-Mulúk, his vizier, and Aziz snuck onto the Camphor Islands in the guise of merchants and set up shop selling fabric in the bazaar. Soon after, an old woman came to their store to purchase fabric for Princess Dunyà. Tàj al-Mulúk gave her the fabric as a gift and slipped her a letter to give Princess Dunyà. And in this way, Tàj al-Mulúk and Dunyà exchanged many letters. Tàj al-Mulúk fell more deeply in love with her, and she began to feel affection for him also, but she refused to change her mind about marriage. The old woman told Tàj al-Mulúk that the princess once had a dream of a female pigeon who was trapped in a net and whose mate did not come to save her. The princess concluded she could never trust men.

Tàj al-Mulúk took this knowledge and commissioned a painting in a garden the princess visited regularly. The painting depicted a female pigeon trapped in a net and her mate caught in the claws of a kite. When Dunyà saw this, she realized she had misinterpreted her dream. So when Tàj al-Mulúk presented himself, she fell deeply in love with him. They consummated their love, and Tàj al-Mulúk remained hidden in the women's quarters, disguised as a young lady for many months. The vizier, not knowing what had happened to Tàj al-Mulúk, summoned the king and his army to rescue the prince. The king arrived, the prince was revealed, and an official marriage was arranged between the lovers.

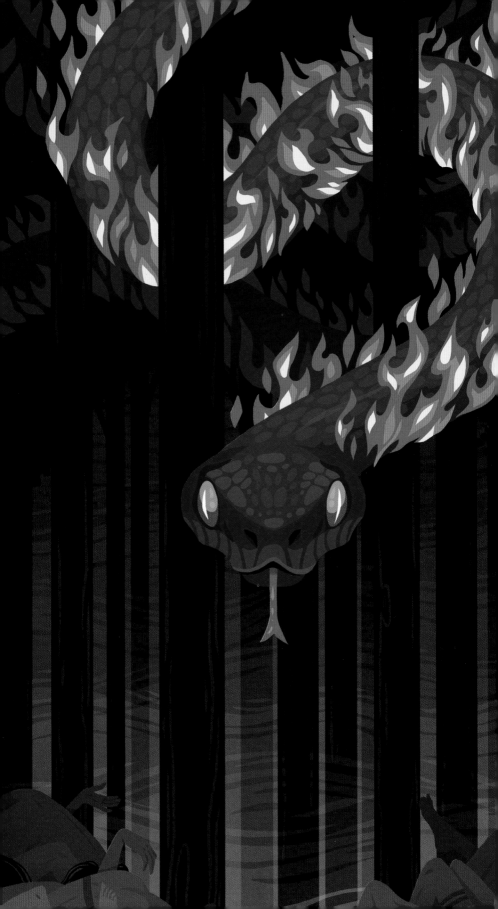

Boitatá

BRAZIL, BRAZILIAN MYTHOLOGY

Legend has it that long ago there once was a night that did not end. Deep in the Amazon forest, the night went on and on, lasting days and weeks and months. In this darkness, the people began to starve because they could not grow crops for food. It was too dark to see anything, too dark even to chop wood to make into torches to burn. It became oppressive, and all the animals and people began to grow scared. Then it began to rain.

The rain went on and on with no end in sight. The forest began to flood, and many of the animals and people, weak with hunger and cold, drowned in the endlessly rising waters.

It was then that a huge snake sleeping on a log deep in the forest woke from its slumber. It woke feeling very hungry. It slithered easily through the wet forest because it knew how to swim and was accustomed to darkness. It began to eat all the dead floating animals, filling its belly to bursting. Eventually, because there were so many animals, the snake was able to feast on only its favorite part—the eyes. The eyes of the animals gleamed bright with the light of the last rays of sun the animals had seen, so with each eye the snake swallowed, the brighter the snake itself became. It ate so many eyes full of light that it became fire and, with its brilliance, banished the rain and the night and brought warmth back to the forest. The snake became known as the Boitatá.

Now the Boitatá is considered a protector of the forests and fields. Its bright eyes can see perfectly in the dark, and it will kill anyone who tries to set fire to the forest, eating their eyes. Anyone who has the misfortune to see the snake will go blind, go insane, or even die.

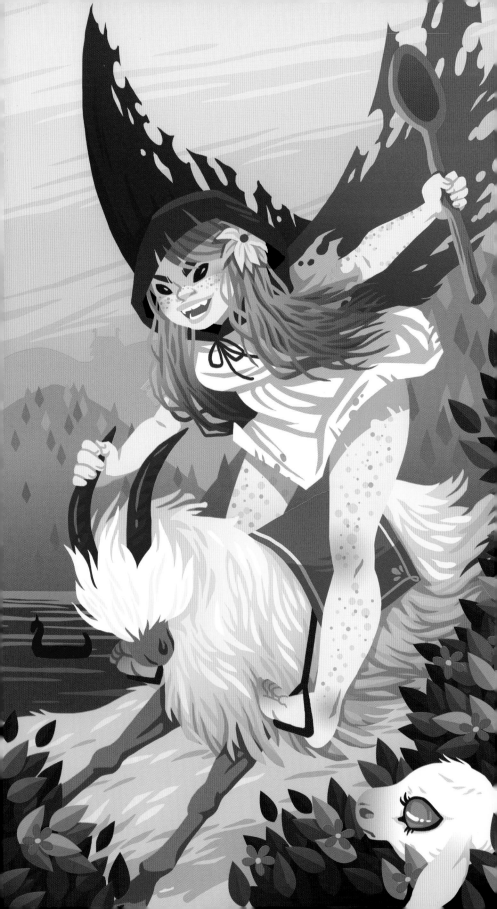

Tatterhood

NORWAY, NORWEGIAN FAIRY TALE

There once was a queen who wanted a child but was never blessed with one. Eventually she found a beggar woman who told the queen to pour her bath water under her bed. In the morning, she would find two flowers growing there. The beggar woman warned the queen to eat only the pretty flower. However, the queen found the pretty flower so delicious that she had to eat the ugly one, too. Nine months later, an ugly and wild baby girl was born wearing a tattered cloak, riding a goat, and wielding a wooden spoon, followed shortly by the birth of a sweet and beautiful baby girl.

The queen was horrified by her hideous child, named Tatterhood, but charmed by the lovely twin. The family grew up happily until the day when trolls came to harass the kingdom. Tatterhood bade her family wait inside while she dealt with the trolls. She got on her goat and began beating the trolls so soundly with her wooden spoon that they howled with fright. This caused the lovely twin to stick her head out to see what was happening. Quick as a flash, the trolls yanked off her head and replaced it with a calf's head before running away.

Tatterhood grabbed her sister and followed them across the sea. Arriving at the trolls' home, Tatterhood beat them all up and rescued her sister's head. After swapping the heads back, Tatterhood brought herself and her sister to a neighboring kingdom, where she demanded the king come meet her. The curious king came to see what the ruckus was about and instantly fell for the sweet princess. The princesses agreed that the lovely princess would marry the king if the ugly Tatterhood would marry the prince. The prince didn't agree to these conditions, but his father forced him to marry Tatterhood.

On the day of their wedding, Tatterhood told her prince to ask about her tattered cloak, her beaten spoon, and her shaggy goat. As he inquired after each, they changed to a beautiful gown, a regal scepter, and a noble stallion, transforming the once ugly Tatterhood into a gorgeous princess. They then lived happily ever after.

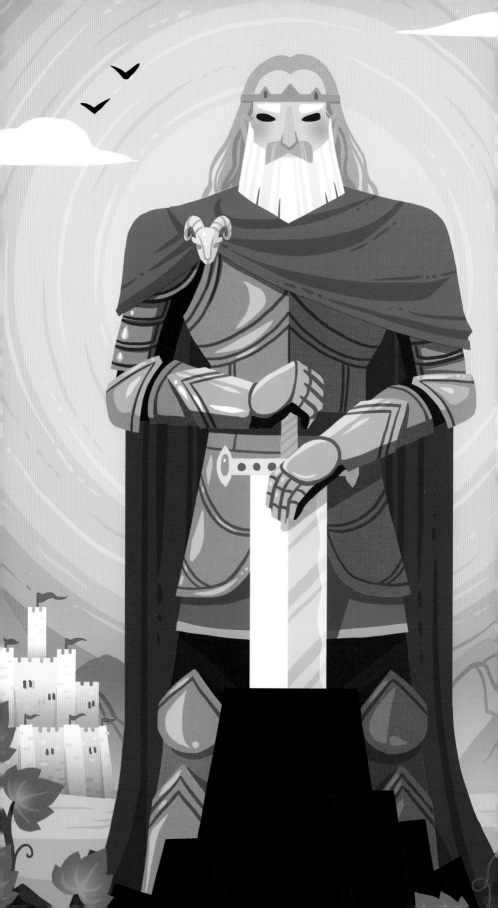

King Arthur

BRITAIN, CELTIC LEGEND

A long time ago, Britain was invaded by the Saxons and its king deposed. Into this chaos a prophecy arose that only the one true king would be able to pull a sword from an ancient stone, a king who would reunite Britain and banish the Saxons. Young Arthur was that one true king, and when he pulled out the sword effortlessly, the people rallied behind him. Aided by a wise old magician named Merlin, King Arthur gathered together the best knights in the kingdom and sat them down at the Round Table in his castle of Camelot.

King Arthur repelled not only the Saxon forces but also supernatural threats, such as the giant cat-monster Cath Pulag, the enchanted and venomous boar Twrch Trwyth, the Cynocephali dog-headed people, the giant Cribwr Gawr, and many more. In one of his more notable adventures, King Arthur journeyed to the lake surrounding the magical Island of Avalon after his sword was damaged. Taking a barge out into the waters, he was greeted by the Lady of the Lake, a magical nymph-like woman named Nimue. She rose out of the water to offer him the enchanted sword Excalibur, granting him more power to banish the dark forces that plagued Britain.

After King Arthur and his knights slew every outside force and vanquished every evil, they were able to reign with peace and prosperity. King Arthur and his queen, Guinevere, ruled fairly and compassionately. They never had any children.

Unfortunately, the peaceful rule came to an end when King Arthur's half-sister, Morgan le Fay, aided the evil Mordred and attempted to usurp the throne. King Arthur managed to slay Mordred but was mortally wounded during the battle. With his dying wish, he commanded that his sword Excalibur be given back to the Lady of the Lake.

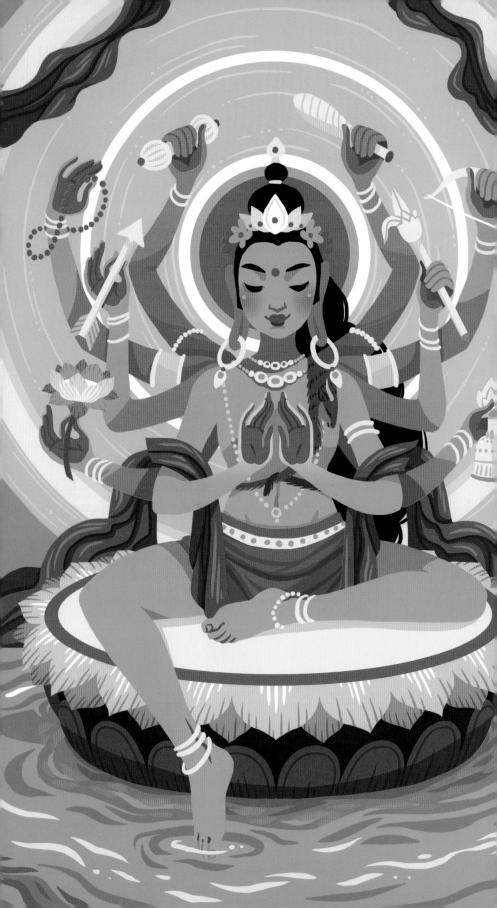

Bodhisattva Avalokiteshvara

INDIA, BUDDHIST BODHISATTVA

Avalokiteshvara, the bodhisattva of compassion, felt compelled to liberate all creatures from suffering. Able to manifest as many different genders, ages, and shapes, Avalokiteshvara looked out upon all the beings in the universe and saw how many of them were embroiled in their sufferings by their attachments and delusions. Being chained to their egos trapped them in the cycle of death and rebirth, and the creatures of the universe were unable to achieve enlightenment.

The bodhisattva was filled with sorrow and, with tears flowing from their eyes, asked the many Buddhas, those who had achieved enlightenment and escaped the perpetual cycle of death and rebirth, to advise them on how to aid all the beings who suffered. The Buddhas told Avalokiteshvara that if they wished to help all the creatures of the universe, they must be motivated by kindness, love, and compassion and must never give up or grow tired of the work. Avalokiteshvara vowed to use compassion to liberate every being in the universe. They used their powers to manifest into the forms needed to aid each individual, including minor kings, generals, monks, beggars, wives, young maidens, children, animals, dragons, monsters, and more.

Avalokiteshvara worked tirelessly and helped many people escape from suffering. But when the bodhisattva looked around, they realized the number of beings suffering had not diminished at all, for the number of creatures was infinite. With that, their head broke into eleven heads, ten with benevolent faces and one with a wrathful face, because sometimes tough love is needed, to better spread the message of enlightenment. Then their arms broke into a thousand arms, each with an eye in the palm, to better see and do the work needed to spread enlightenment.

Note: Avalokiteshvara were the most popular and famous of the bodhisattvas. And it is believed that everyone has been touched by them at some point in their life.

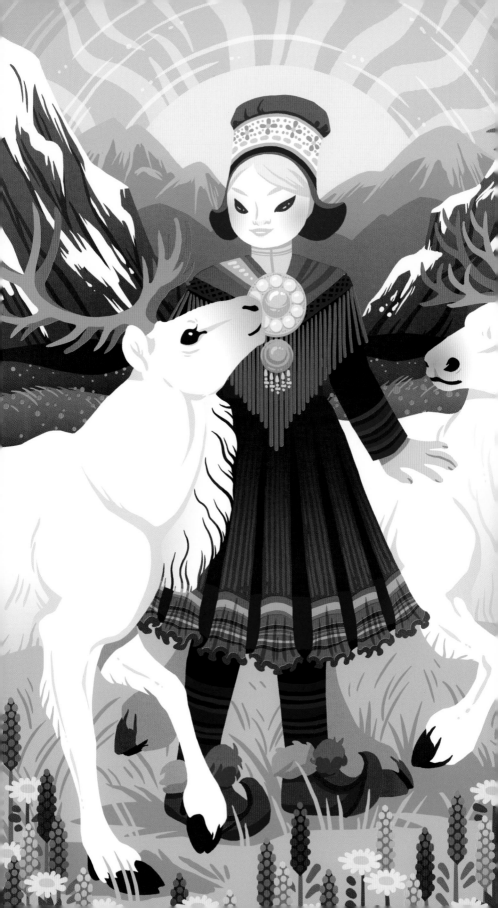

Beaivi-nieida

SWEDEN, SAMI DEITY

High up north in the Arctic Circle, the winter is long and dark with the sun remaining dim and hidden for long stretches of time. There the Sami people have lived and herded reindeer while waiting for the return of the Sun Goddess, Beaivi, and her daughter, Beaivi-nieida. Deep in the winter, the absence of Beaivi and Beaivi-nieida and the long darkness negatively affected the mental health of those on Earth. During this time the goddesses became weak, so sacrifices of white reindeer were made to give them the strength to return. Female reindeer, which are the fastest, were the best offerings.

In the spring, Beaivi returned to the sky. Frozen butter melted, the world bloomed, and the reindeer flourished. She blessed those whose mental health deteriorated during the winter. She and her daughter, Beaivi-nieida, rode high into the sky in a sled made of antler horns, and they brought fertility and life to the earth. In the summertime, the reindeer gave birth to their calves, and a porridge made with rich, fatty reindeer's milk was offered to the goddesses in thanks.

There was once a time, long ago, when Beaivi-nieida left her mother in the sky and went to join the people on Earth. She was light and goodness and shared her knowledge of many things with the people. At first the people appreciated her and enjoyed learning storytelling, embroidery, button-making, sea songs, and many, many other skills. But eventually they grew bitter and jealous of her endless talents and sought to kill her. They trapped Beaivi-nieida and crushed her beneath a giant rock, so she returned to the sky to be with her mother, the Sun Goddess. She hasn't come back since.

Sedna

There once was a beautiful woman named Sedna who lived in the far northern snows. There came a time when Sedna was old enough that her family wished for her to be married. But Sedna did not want to get married. She found fault with every one of her suitors and threatened to marry a sled dog instead.

Her father was furious with her. So when a handsome and mysterious hunter appeared in their village asking to marry Sedna, he readily agreed. The unknown hunter promised to give the family plenty of meat and furs in exchange for her hand, and Sedna decided to consent. After they married, he took her away to his island. Once there, he revealed to her that he was not a man at all, but a bird that had been disguised as a man. Sedna was livid with this deception and even angrier because, as a bird, he was not a very good hunter. He caught and fed her only fish, so she had no meat or furs. But she was stuck on the island, and she tried to make the best of it.

Finally, Sedna's father came to visit and instantly saw how miserable Sedna was. He also realized that the mysterious man had been a liar. He killed the bird, put Sedna in his kayak, and started for home. But the bird's family, upon finding him slain, screeched in anger. They set out to avenge him, beating their wings so hard they started a storm. The tiny kayak was soon overwhelmed, and Sedna's father, desperate to appease the birds and save himself, threw Sedna overboard. Sedna quickly grabbed on to the side of the boat and would not let go, so her father drew his knife and sliced off her fingers. Sedna raged as she sank to the bottom of the sea, and she became a wrathful sea goddess. Her fingers became seals and whales, and her hair grew to entangle all the sea creatures of the world.

Now if people want to hunt in the ocean, they must appease Sedna and pray for her to release the sea creatures from her grasp.

Vasilisa the Beautiful

RUSSIA, RUSSIAN FAIRY TALE

A merchant and his wife had a sweet and kind daughter known as Vasilisa the Beautiful. When Vasilisa was still young, her mother died. On her death-bed, she gave her daughter a small wooden doll and told her to give the doll a little to drink and a little to eat and the doll would comfort her. When her mother died, the girl did just that and felt soothed by the doll's presence.

Time passed, and the merchant married a woman with two daughters. The stepmother was jealous that Vasilisa was preferred by the young men over her own daughters, so the stepmother set out to be rid of her. When the merchant left on a long trip, Vasilisa's stepmother moved the four of them to a gloomy hut in the forest. She then put out all the fires in the house and bade Vasilisa go fetch light from their neighbor, Baba Yaga.

Gaining comfort from her doll, Vasilisa traveled the dark woods to Baba Yaga's home, a house on chicken legs and surrounded by a fence topped with human skulls full of light. As a terrified Vasilisa waited outside the fence, a rider dressed all in white rode past on a white horse, then a red rider, then a black rider. Finally, the old crone Baba Yaga herself rode up in her mortar.

Baba Yaga agreed to give Vasilisa fire, but only if she completed some impossible tasks. If Vasilisa couldn't complete them, she would be killed. Vasilisa began to fret as she attempted the tasks, for she was unable to separate poppy seeds from a pile of dirt, or rotten corn from good corn in a single day. But when all hope seemed lost, her little doll told Vasilisa to sleep, for she would do all the work.

When a surprised Baba Yaga asked how Vasilisa was able to complete the tasks, the girl explained that she was blessed by her mother. Horrified, Baba Yaga told Vasilisa she wanted nothing to do with blessed people. She kicked Vasilisa out of her house, sending her home with a skull-lantern full of burning coals. When Vasilisa arrived back at the hut, the skull magically burned her stepmother and stepsisters to ashes.

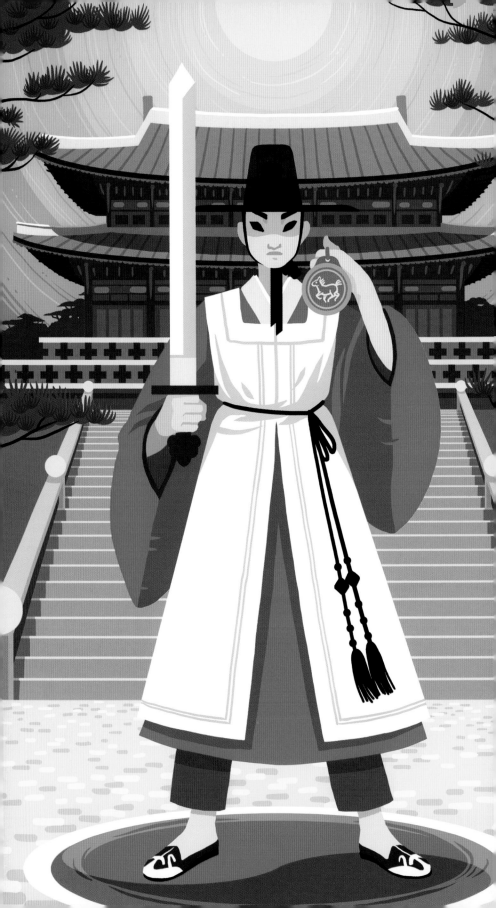

Amhaeng-eosa

KOREA, KOREAN LEGEND

The Amhaeng-eosa, or Secret Royal Inspectors, were real historical figures, appointed by the king, with the power to punish the corrupt and promote the deserving. They would secretly enter provinces and use their undercover identities to investigate government officials. They would then reveal themselves with their *mapae*, the medallions that proved their dominion. While real, they were popularized in dramas and literature, even during the Joseon period, and became mythologized.

One of the most famous tales is the story of Chunhyang. In this tale, the handsome Yi Mongryong fell in love with and married the beautiful Chunhyang. Unfortunately, he had to move to Seoul to train to become an Amhaeng-eosa just as a new government official, the vile Pyon, took control of the area. Chunhyang vowed to wait patiently for Yi Mongryong and gave him a ring to remember her by. But when he had gone, the greedy Pyon attempted to add the lovely Chunhyang to his courtesan party.

Chunhyang tried to rebuff Pyon's advances, which enraged the pompous man, and he imprisoned her. Meanwhile, Yi Mongryong passed the Amhaeng-eosa test and secretly returned to the village to find the mess Pyon had created. Yi Mongryong remained undercover as a beggar and learned about Pyon's crimes, such as neglecting his duties, throwing lavish parties, and generally abusing his power to terrify the populace. Then, at Pyon's birthday celebration, just as the government official was about to punish the loyal Chunhyang, Yi Mongryong revealed himself to be a secret Amhaeng-eosa and condemned Pyon for all his wrongdoing. Pyon was then deposed and a new and just official given the position.

Meanwhile, Chunhyang, happy to be rescued, did not initially recognize Yi Mongryong and rejected his affections. It was only when he returned her ring to her that she realized who he was. Chunhyang was overjoyed, and the couple lived happily ever after.

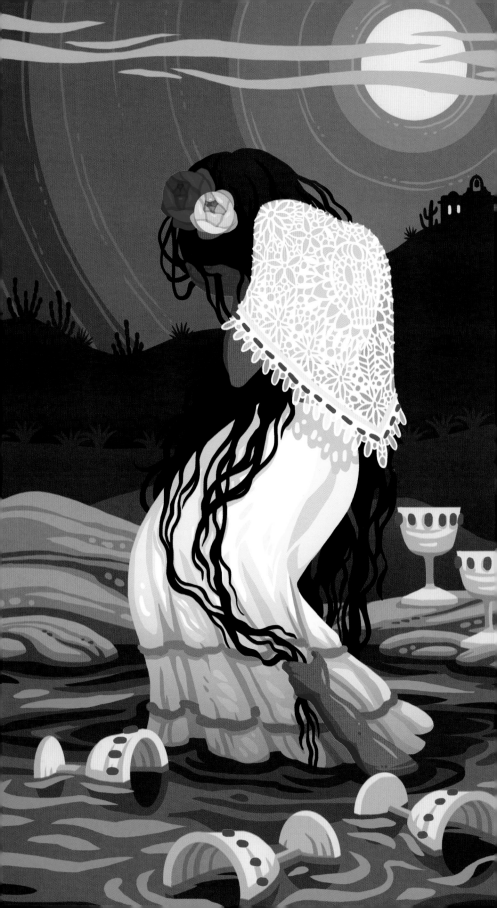

La Llorona

MEXICO, MEXICAN FOLKLORE

There once was a young girl named Maria who lived in a small village. Though her family was very poor, she was very beautiful, so she eventually caught the eye of an extremely wealthy man. He was riding through her village one day when he spotted her and, captivated by her charms, instantly proposed to her. She was dazzled by him. Encouraged by her family, she accepted him.

His family was less supportive, so he built a house for her in the small village that he would visit. Maria bore him two handsome sons, and they were quite happy for some time. But her husband was constantly traveling, and he began spending less and less time with his small family. Then he began to ignore Maria and only pay attention to their sons. Eventually he stopped appearing altogether. When she finally saw him again, he was with another woman who was from a prosperous family.

Furious to the point of losing her senses, she took her rage out on his sons. She brought the children to the river and drowned them.

When she realized what she had done, she was filled with remorse and sorrow, for of course she had loved her sons. She searched and searched for them, but their bodies were gone. So she drowned herself in the river.

When she arrived at the gates of the afterlife, Maria was denied entry without her children. Maria was forced to return to Earth and, stuck between the living and the dead, began to search for her children. To this day she still searches, kidnapping children who wander alone at night and drowning them to replace her own children. She can be heard crying, "¡Ay, mis hijos!" or "Oh, my children!" This is why she is now known as La Llorona, or the Weeping Woman.

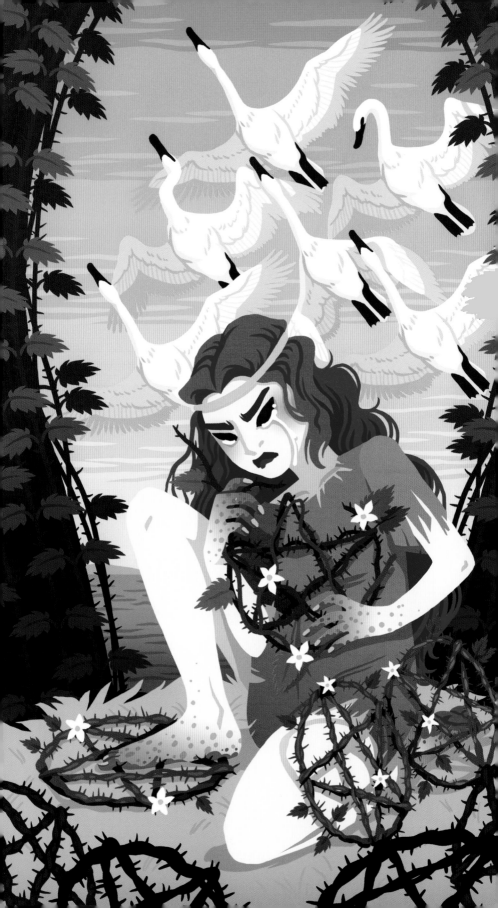

Six Swans

GERMANY, GERMAN FAIRY TALE

There once was a king whose wife died, leaving him to raise his six sons and a single daughter. Soon the king married a mysterious woman from the forest. Jealous of the sons, she snuck into the princes' room and transformed them into swans, banishing them to the wild. The woman claimed the sons had died, but the princess didn't believe her, and she ran away to the woods. There she met a fairy who told her that her brothers had been cursed, but the spell could be broken if she made each of them a shirt of stinging nettles and did not speak while making them.

The swan brothers found their sister and, learning of her task, flew her across the sea to a new land, where they built her a small home. There she worked tirelessly for years, picking the nettles with her bare hands, crushing them with her bare feet, and weaving and sewing the shirts all by herself without uttering a single word.

One day as she was working, the king of that country spied her and fell in love with her beauty. He coaxed her back to his castle, where she lived under his protection. Though he gave her gifts and kindness, she never spoke but only smiled and continued about her work. The king fell more deeply in love with her, but his mother only despised her. Searching for a way to ruin her, the dowager queen accused the princess of being a witch who wove evil shirts out of nettles. The princess, unable to speak in her defense, was sentenced to burn at the stake.

The princess only stitched more furiously, and on the day of her execution, she had made all the shirts except the sleeves on the last one. As the pyre was about to be lit, the six swans appeared, and she gave each one a shirt. They each transformed back into a man except the youngest, who still had the wings of a swan. Free to speak, the princess told her tale. The people were in awe of the miracle, and the princess married the king of that new land. They lived happily ever after.

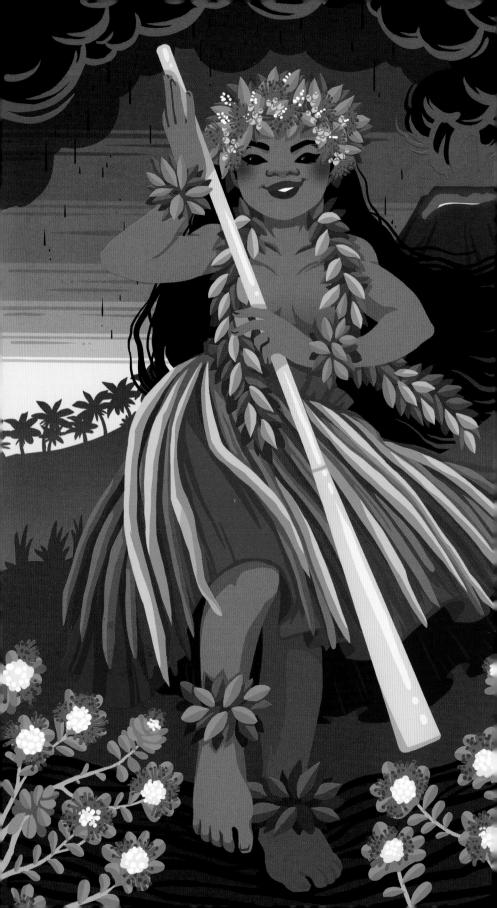

Pele

HAWAI'I, HAWAI'IAN MYTHOLOGY

There are many gods and goddesses of the islands of Hawai'i, and one of the most famous is the volcano goddess, Pele. Pele was born to the earth and fertility goddess, Haumea, and to the ferocious god Ku-waha-ilo. In the beginning she lived in peace with her many siblings, but peace did not last. Pele used her *pa'oa*, a long stick used to till land, to turn the earth and draw up lava. The lava brought rich nutrients for life, but it also brought fire and death. Her older sister, Na-maka-o-ka-hai, was a goddess of the sea who felt a bitter rivalry with Pele and a fear the goddess of fire would eventually burn their home.

So Na-maka-o-ka-hai drove her sister from their home with floods of water. Pele then took some of her siblings in the canoe Honuaiakea and traveled in search of a new residence. Together they traveled far and eventually landed on the islands of Hawai'i. At each island a few of her siblings, various deities of wind, rain, fire, ocean, and cloud, disembarked and made their new homes. But Na-maka-o-ka-hai kept flooding and driving Pele on until Pele arrived on the biggest island, where she resides to this day in the volcano Kilauea.

But Pele has not been quiet during all that time. She is a powerful goddess, but she is also passionate, prone to jealousy and capriciousness. She has had many lovers and does not take rejection well. Once she fell for the handsome warrior Ohia, but he was already in love and pledged to the beautiful Lehua. Furious, Pele turned Ohia into a twisted tree. Lehua was heartbroken, so the gods took pity and turned her into a blossom that grew on the tree so they might be together forever. To this day, Ohia trees with Lehua blossoms are the first things to grow after lava has cleared the land.

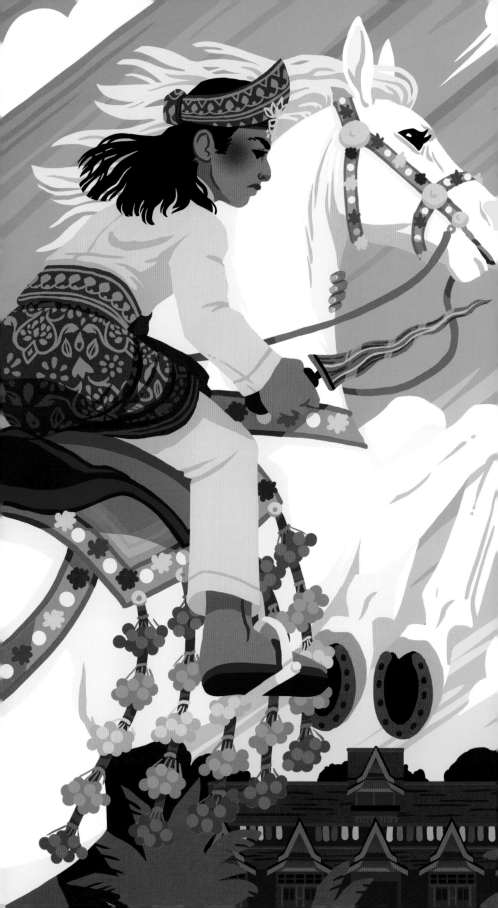

Hang Tuah

One of the most famous warriors of Malaysia is Hang Tuah, a powerful *laksamana*, or admiral, and a Silat martial arts master.

Hang Tuah was raised as a woodcutter in his parents' shop, but his strength and martial prowess led him to the teacher Adi Putera. Adi Putera trained Hang Tuah and his four friends, Hang Kasturi, Hang Lekir, Hang Lekiu, and Hang Jebat, in the art of Silat and meditation. The five companions became highly skilled, and their ferocity soon became known far and wide.

One day a gang of men began terrorizing an area near Kampung Bendahara. They were so brutal that even the region's top guards were frightened off. But Hang Tuah saw this, and he and his companions attacked the gang with such power and skill that the gang ran away. The head of the guards was so impressed by Hang Tuah and his friends that he presented them all to Sultan Muzaffar Syah.

Hang Tuah quickly became the sultan's most loyal laksamana, and his skills and deeds became legendary. On a visit to Majapahit, Hang Tuah fought and won a brutal duel with Taming Sari, a famous *pendekar*, or Silat master. As a reward, the ruler of Majapahit, Singhavikramavardhana, bestowed on Hang Tuah the Keris Taming Sari, a magical dagger that imbued its wielder with invulnerability.

Hang Tuah also helped the sultan marry the beautiful Tun Teja. Tun Teja was the daughter of Seri Amar Di Raja Inderaputra, royal chief minister of Pahang. Though the sultan had asked for her hand in marriage, he was denied for political reasons. So with gifts and a love potion, Hang Tuah stole Tun Teja away. When her father discovered what had happened, he sent ships after Hang Tuah, and a fierce battle broke out. Hang Tuah eventually won, and delivered Tun Teja to the sultan, whom she agreed to marry. Hang Tuah served the sultan and eventually served the sultan's successor for many more years.

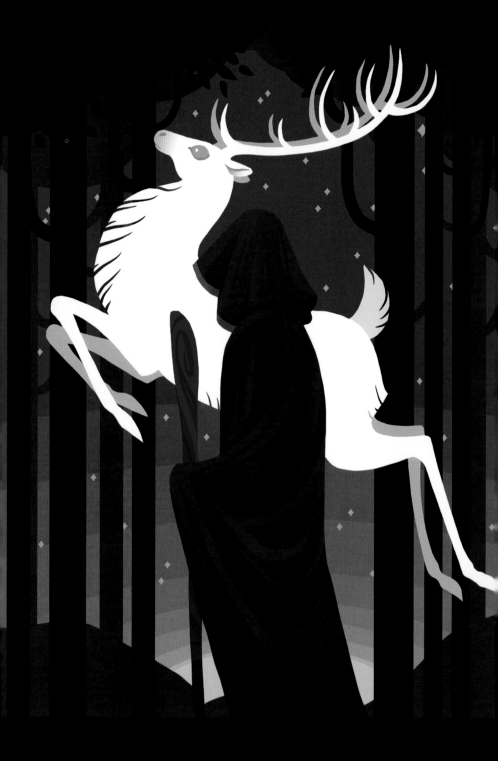

Druids and the White Stag

IRELAND, CELTIC LEGEND

Druids and the White Stag were part of the ancient Celtic tradition. Druids were men and women who were religious leaders, legal authorities, lore-keepers, adjudicators, medical professionals, and political advisers. They passed down their teachings orally, and it took many years of study to be considered a full Druid. All Druids were considered wise and very studious. In mythology, they often wielded magic and had the ability to predict the future.

The White Stag is a magical creature of Celtic legend sometimes considered a messenger from the underworld. It's an elusive animal, notably impossible to catch and preternaturally good at evading capture. It features in a number of Arthurian myths heralding the beginning of a quest, symbolizing mankind's perpetual spiritual journey.

One famous Druid was the warrior Bodhamall, the woman who raised the famous Fionn mac Cumhaill, leader of the Fianna. The story began when Cumhaill was killed and replaced by his rival, Goll mac Morna. Cumhaill's wife, Muirne, daughter of Druid Tadg mac Nuadat, feared for their unborn son. She fled to the safety of Cumhaill's sister, the warrior Druidess Bodhmall, and her companion, the fierce warrior Liath Luachra. In their secluded home, Muirne gave birth to her son, Fionn, and left him to be raised by the two women. Bodhmall and Liath Luachra taught their foster son, Fionn, all they knew of the Druid arts and warrior ways, accompanying him on many adventures until he grew old enough to confront Goll mac Morna.

Other famous Druids included Cathbad, who predicted tragedy and fortune in equal turns. Another was Amergin Glúingel, a Druid who was able to summon a magical storm to prevent enemy ships from landing. There was also the Gallizenae, a group of female priestess Druids who lived on a secluded island and had the ability to rouse the sea and the wind by their incantations, to turn themselves into any animal form, to cure diseases, and to foretell the future to those who consulted them.

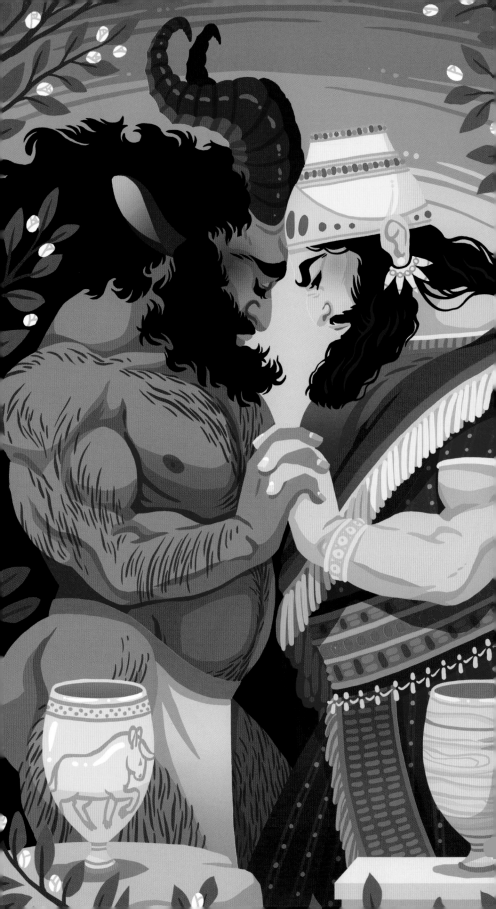

Enkidu and Gilgamesh

IRAQ, SUMERIAN MYTHOLOGY

Gilgamesh was the great king of Uruk. Born two-thirds divine and one-third mortal, he had no equal in strength or vigor. His endless energy made him an oppressive ruler for he never tired. He demanded attention, celebration, and love at a rate that no normal human could keep pace with. The people of his kingdom eventually grew so exhausted that they begged the god Anu for help. Anu decided to create the wildman Enkidu to defeat Gilgamesh. Where Gilgamesh was an insatiable man full of culture and civilization, Enkidu was made the solid force of an untamed beast.

The first time Gilgamesh met Enkidu, he found the wildman's stubbornness infuriating and challenged him to a wrestling match. Used to his divine strength easily giving him the upper hand, Gilgamesh was surprised to find his match in Enkidu. The two were so equal in strength that they grappled for days with neither gaining the advantage. Finally, Gilgamesh managed to win by a sliver, but he was so impressed by the wildman that they instantly became friends, and they never wished for the company of another.

The two became inseparable, going on many adventures and defeating many monsters together. This lasted until Gilgamesh made the mistake of insulting the goddess Ishtar, daughter of the god Anu. Ishtar demanded revenge and asked Anu to send the Bull of Heaven to kill Gilgamesh. However, in an unexpected twist, Gilgamesh managed to defeat the bull. Anu demanded retribution for his prized bull, and instead of killing Gilgamesh, he killed that which Gilgamesh loved most—Enkidu.

A devastated Gilgamesh, driven by grief of the death of his beloved Enkidu and fear of his own mortality, decided to seek out immortality. On the journey, he faced many trials and tribulations and was given tasks that, without Enkidu, even he was unable to complete. He returned home to Uruk a mature man and learned to accept death.

Hah~nu~nah, the World Turtle

NORTH AMERICA, IROQUOIS MYTHOLOGY

In the beginning, there was an island floating in the sky, with a large tree in the middle that provided light and nourishment. On this island, there was no birth or death or sickness or sadness; all the inhabitants lived peacefully and happily. That is until Sky Woman revealed she was pregnant and her husband, the chief, uprooted the great tree and pushed her into the hole. As she slipped down, Sky Woman grasped the branches of the tree and managed to pull some seeds down with her. She fell through the floating island and down through the clouds to the ocean below.

Two water birds saw her plummet down. They rose up to catch Sky Woman on their backs, but she was too heavy to hold on to for long. When they brought her to the other animals, it was decided she needed a more solid place to stay. Beaver dove down to the ocean floor to retrieve some earth, but he drowned. Duck also tried, but he also drowned. Finally, musk-rat dove down, and a long time later he brought up a paw-ful of dirt. The dirt was then given to the large turtle Hah-nu-nah—for he was the only one strong enough to support the world—and it was placed on his shell.

The dirt grew and grew and became the earth, supported on the back of Hah-nu-nah in the ocean of the cosmos. The birds placed Sky Woman on this new earth, and she opened her hands and dropped the seeds of the great tree from the floating island. These seeds flourished and created the many different trees and grasses on Earth. Sky Woman then gave birth to twin sons. Sapling was good and sweet, and he created rivers and fish and delicious edible plants. Flint killed his mother by forcing his way out of her armpit, and he made the rivers flow in only one direction, gave the fish many tiny bones, and covered berry bushes in thorns. The brothers took their mother's body and, from pieces of her, made the sun and moon.

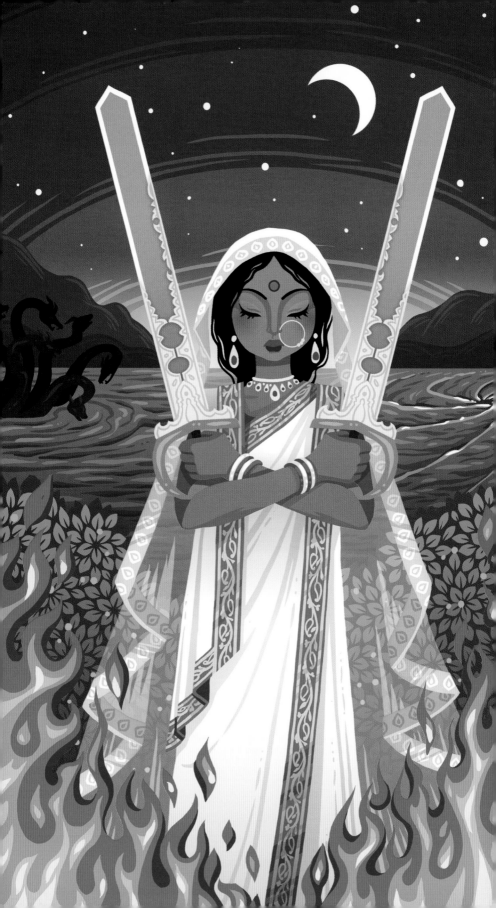

Sita of the Ramayana

INDIA, HINDU EPIC RAMAYANA

Dasharatha was the king of all of Ayodhya, and though he had three wives, he had not a single child. He performed a fire sacrifice and was finally blessed with Rama, Lakshmana, and Bharata, all of whom were endowed with traits of the Supreme Trinity Entity, Vishnu. Vishnu had decided to be born as a mortal, for only a mortal could defeat the demon king Ravana. So when the child Rama was sixteen, the great sage Vishwamitra taught him and his brother Lakshmana how to defeat demons, giving them supernatural weapons.

In nearby Mithila, King Janaka was plowing the fields one day when he found a baby girl in a deep furrow. He took her in and named her Sita, and she grew to be unmatched in beauty and grace. Janaka decided that the only person deserving of Sita was a suitor strong enough to use the heavy bow given to his family by the god Shiva. Rama heard of this bow but was so strong that he broke it when he tried to use it. And so Rama and Sita married.

Through the jealousy and treachery of his stepmother, who wanted Bharata to succeed, Rama was exiled from Ayodhya. He was followed by his loyal wife, Sita, and his best friend and brother, Lakshmana. The demon king Ravana, hearing how Rama had defeated a number of demons, kidnapped Sita as revenge. He brought her back to his home, where she repeatedly refused to marry him, staying loyal to Rama. After many attempts, Rama was finally able to defeat Ravana and free Sita.

But vile rumors about Sita and her time with Ravana arose, and Rama asked her to prove her purity by undergoing the test of fire, called Agni Pariksha. Caught between two difficult choices, Sita stepped into the fire. There the god Agni protected her, proving her innocence, and she and Rama returned to Ayodhya.

The Beauty and the Beast

CHINA, CHINESE FAIRY TALE

Once upon a time, there was a man who had three daughters, all greatly skilled in embroidery. The father, doting on his children, would regularly pick flowers on his way home to inspire his daughters. But one day he couldn't find a single flower along the path. In search of a flower, he accidentally wandered into the domain of the Beast.

Furious that this man disturbed his garden, the Beast threatened to devour the man. Terrified, the man begged forgiveness, saying he only wanted a gift for his daughters. The Beast then promised to let the man go, but only if the man promised to send one of his daughters to marry him. The man reluctantly agreed.

The man returned home to his daughters, but feeling guilty, he told them nothing of the deal he had made. But insects sent by the Beast came to harass him more and more each day until he finally confessed the whole story.

Upon recounting the unfortunate tale to his daughters, the elder two refused to marry the Beast. Only the youngest one acquiesced. She returned to the Beast and was terrified by his giant teeth and glinting eyes. But over time she became used to him. She performed the domestic tasks of his beautiful home, and he was very kind to her. And in this way, she came to like his company.

However, one day she heard her father was sick and begged the Beast to allow her to return to him. He granted her permission to take leave. Coming back many weeks later after her father had recovered, she found the Beast dying of loneliness and thirst. She quickly pulled him to the river and plunged him in. He emerged transformed into a handsome man. He told the surprised beauty that he had been cursed, but her love had set him free.

From that day on, they brought gifts to her family and lived happily ever after.

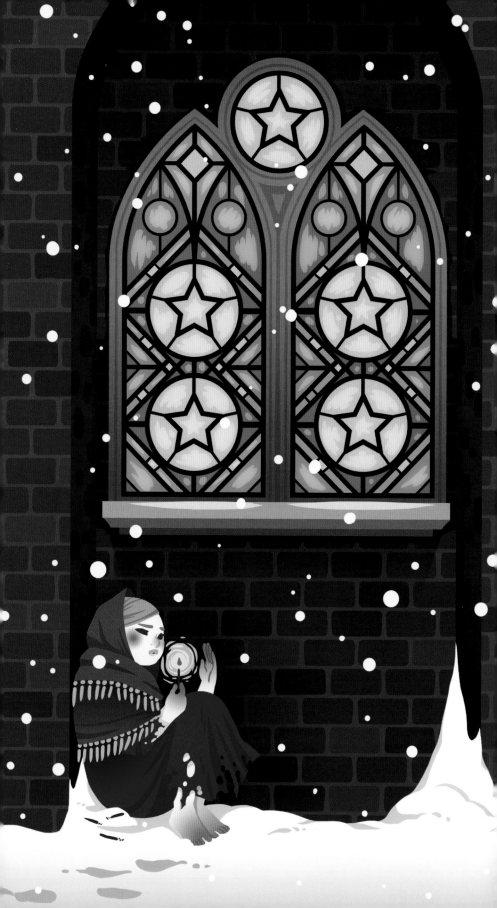

The Little Match Girl

DENMARK, DANISH FAIRY TALE

There once was a poor little girl with bare feet who sold matches on street corners to make a living. But one New Year's Eve, no one needed matches, and no one bought from her. As the snow began to fall, the little girl was too scared to go home penniless to her cruel father. So she found a small corner outside and bundled herself up as best as she could. But as the sun set, it got darker and colder, and the little girl couldn't feel her fingers anymore.

Out of desperation and wanting just a little bit of comfort, the girl took a single match from her bundle and lit it. When the tiny flame burst to life, she warmed her fingers by it, and the warmth felt like a warm, friendly iron stove—she could almost see its brass details. But when the match burned out, the vision and cheer went with it, and the little girl was once again cold and miserable. So she lit another match, and this time she saw a delicious holiday feast with a roast goose and apple stuffing. Again the vision vanished with the flame. The third match showed a magnificent Christmas tree with all the trimmings and finery until it too snuffed out, leaving a single star in the sky that plummeted to Earth.

The little girl remembered shooting stars and how her late grandmother, the only person who was ever loving and kind to her, told her a shooting star meant someone was dying in that moment. She lit a fourth match and saw her grandmother before her, just as kind and sweet as ever. The girl feared that, like the visions before, her grandmother would disappear when the match burned out. So she lit the entire bundle. In the bright blaze, her grandmother smiled and took the little girl's hand. Together they flew into the sky, where there was no cold or hunger or worry.

The next morning, people found the little girl dead and frozen solid in the snow. But none saw her gentle smile or knew her happiness.

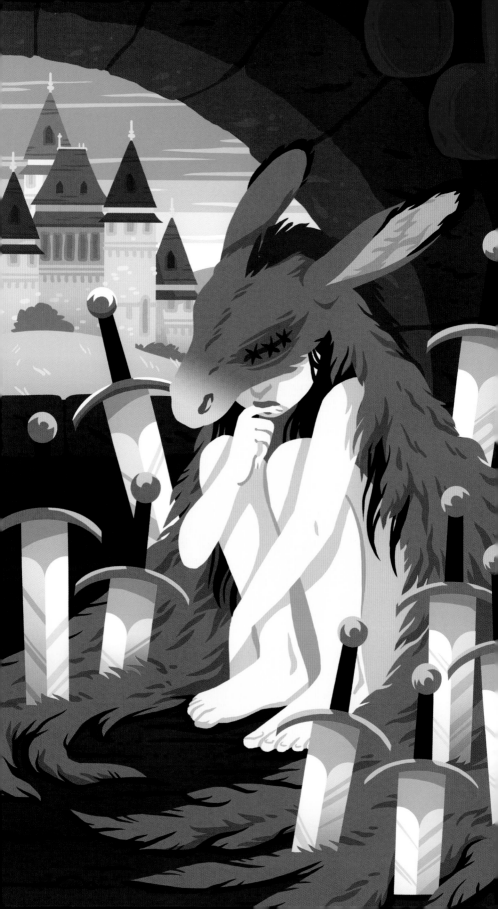

Donkeyskin

FRANCE, FRENCH FAIRY TALE

There once was a handsome king who had a donkey whose droppings were gold. The king married the most beautiful woman in all the world, and together they had a daughter and lived in peace in their prosperous kingdom. But one day, as the queen lay on her deathbed, she made the king promise not to marry again unless his new wife was as beautiful as she was. He agreed, and soon the queen died. Devastated, the king then tried to find a new wife, but he realized that only his own daughter was beautiful enough to fulfill the promise.

The princess was mortified and asked her fairy godmother for help. Her fairy godmother advised that she make impossible demands of her father before giving her consent. So the princess asked for a dress as bright as the sun, a dress as mysterious as the moon, a dress as brilliant as the stars, and, last, a cloak made out of the skin of the marvelous gold-producing donkey. When the king did all of these things, including slaying the donkey that brought the kingdom wealth, they realized how determined the king was, and the princess put on the donkeyskin cloak as a disguise and fit all three of her dresses into a magical walnut.

The princess fled to another kingdom, where she began to work in the kitchens of the royal castle. There she remained hidden in her ugly donkeyskin, but on feast days she wore her brilliant dresses. The local prince happened to see her one day and fell in love with her at first sight. He grew sick with longing and refused to eat anything unless it was made by the girl in the donkeyskin. The others balked at her ugliness, but the disguised princess made the prince a cake with her ring baked into it. He found it and said he would marry whomever the ring fit. When the ring failed to fit anyone else, the hidden princess came forward and slipped on the ring. She then changed into her splendid dresses and revealed herself. The prince and princess were married and lived happily ever after.

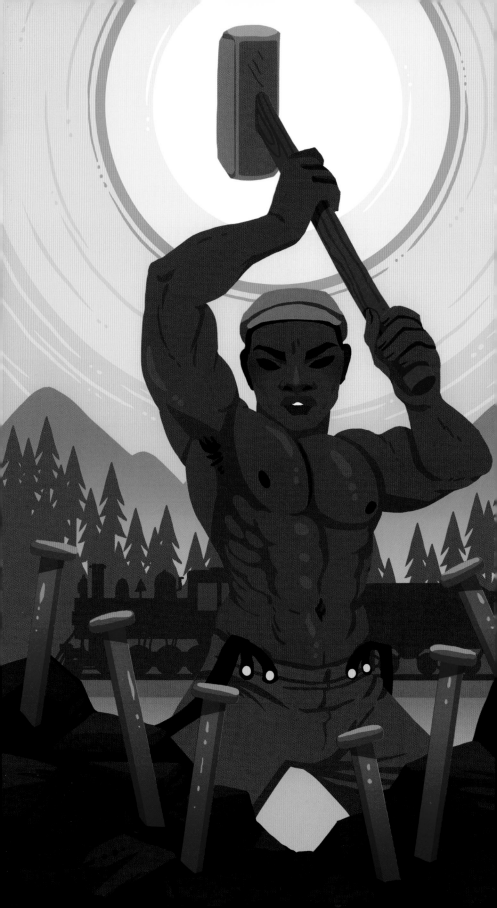

John Henry

ALABAMA, AMERICAN FOLKTALE

A legend is told in the Southern United States that not too long ago there was a man named John Henry. John Henry was born a slave and was freed during the Civil War. After receiving his freedom, he struck out to make his fortune and found a job with a railroad company. The train was becoming increasingly popular, and to keep up with demand, the railroad companies were laying down more and more track to connect the east with the west. And in order to lay down track, large swaths of land had to be cleared, rocks broken, and even hills cut through.

John Henry was a giant of a man with a huge appetite for hard work done well, so he was a natural steel driver. Steel drivers, sometimes known as hammer men, would hammer thick steel spikes into rocks to make holes into which explosives would be dropped to blast away the rock. A steel driver was always assisted by a shaker, who would crouch by the hole and spin the spike after each hammer. Together, an average steel driver and a shaker could do a good day's work. But John Henry was no average man. His hammer was fourteen pounds, and he could drive it for ten to twelve hours a day, faster and longer than anyone else.

There came a time when John Henry's railroad company arrived at a mountain that they could not bypass. They had to bore through it with the steel drivers' hammers and drills. At this moment a salesman arrived. He told the railroad company that his new steam-powered drill could bore through the mountain faster and longer than any man. He claimed that with the drill, the railroad company didn't need any other workers and could let them go.

John Henry refused to accept this. Defending the rights of the workers, John Henry agreed to the challenge and lifted up an even heavier hammer. The race began. The engine chugged and the man swung, and both were such a blur they were impossible to track. When the race ended, John Henry's heart burst from exhaustion, but he had won: the engine had drilled nine feet; John Henry had drilled fourteen!

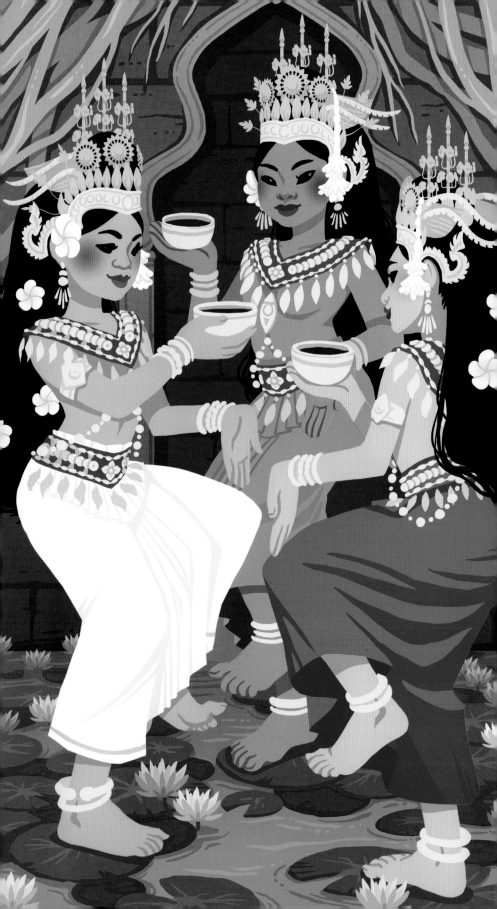

Apsaras

CAMBODIA, HINDU MYTHOLOGY

Indra is the powerful god of lightning, thunder, storms, rains, river flows, and war. He is also the king of heaven and of the Devas and Devis, or male and female heavenly beings. He is recognizable by the lightning thunderbolt vajra he wields and the three-headed white elephant, Airavata, he rides. But he is also known for having huge debaucherous parties. He surrounds himself with Gandharvas, male nature spirits who are excellent musicians, and their female counterparts, the dancing Apsaras. Apsaras are beautiful and supernatural women who delight in entertaining. They rule over the fortunes of gaming and gambling; they are each a patron of a distinct aspect of the performing arts; and they are all accomplished dancers. They fly through the skies delivering messages and seduce men and gods alike. Indra once even sent the Apsara Menaka to seduce the sage Vishwamitra to distract him from his meditation and prevent him from gaining power. The Apsaras usually marry their musician companions, the Gandharvas. That is, except for Mera.

Mera was the queen of the Apsaras, and though her sisters married the heavenly musicians of Indra, she herself was bored with them. She felt jaded and depressed, thinking that she would never find love in heaven. And so she looked down to Earth and the green land of Cambodia. There she spotted the sage-king, Kambu Swayambhuva, who had traveled to Cambodia from distant India. She was so enraptured by his kindness, his valor, and his exotic origins that she descended from the sky and forsook her heavenly luxuries and even her immortality to be with him. The god Shiva blessed their union, and they married and created the Cambodian monarchy. Through their children, they gave rise to the Khmer people, named through the combination of their names, Kambu and Mera.

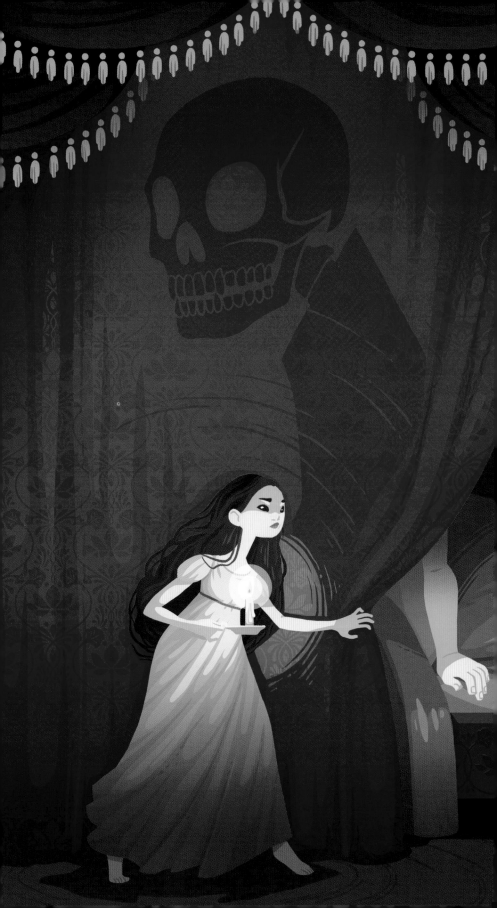

The Bear King, Valemon

NORWAY, NORWEGIAN FAIRY TALE

There once was a woodcutter with three daughters and very little money. But one day, a giant white bear arrived at their doorstep and promised the family many riches if one of the daughters would come live with him in his castle. Though the two elder daughters were pretty, they were terrified of the bear. Only the youngest, who was also the sweetest, agreed to the bear's conditions and climbed up on his back.

The bear carried her far and away to his huge castle, where all her needs and desires were met during the day. At night, something would climb into her bed to sleep beside her, though she never saw what it was.

After she had been there for some time, she asked the bear for permission to visit her family. He agreed but made her promise not to listen to what her sisters said. Her sisters, upon learning of the mysterious nighttime visits, convinced her to take a candle to bed to see what was next to her. The very next night, she lit the candle and found that the something was a beautiful man. Three drops of wax fell on his shirt, and he awoke with a cry. He told her he was King Valemon, and he had been cursed to be a bear, but now that she had seen him, he was forced to marry the troll queen's daughter. In a flash, he and his entire castle disappeared, leaving her cold and alone.

She set out to find him, recruiting the help of the North Wind to take her to the troll queen's palace, which was west of the sun and east of the moon. She found him right before the wedding was to begin and challenged the troll princess to a battle. Whoever could clean the wax from the king's shirt would get to marry him. The troll princess agreed, but when she tried, her black heart only made the shirt become filthier. The woodcutter's daughter took it next, and with her pure heart, the shirt became as bright and clean as new.

The trolls conceded defeat, and the couple was soon married and lived happily ever after.

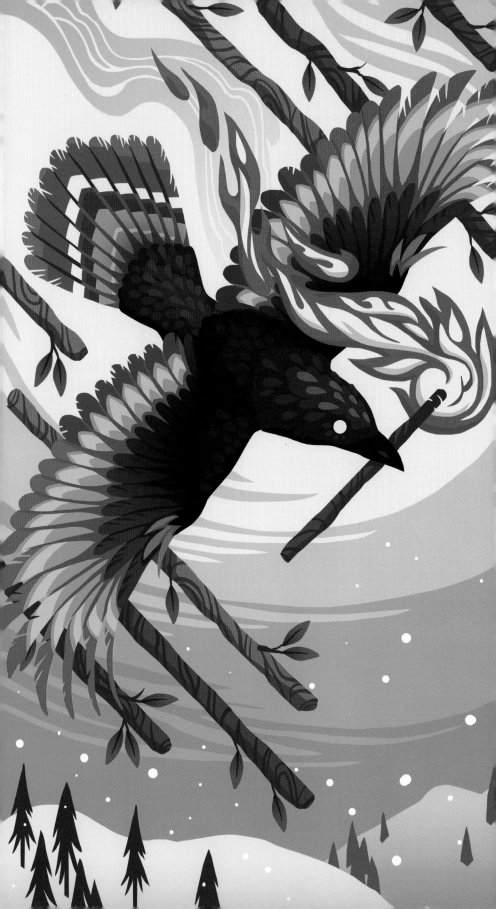

Rainbow Crow

NORTH AMERICA, LENAPE PEOPLE (DISPUTED)

Back when the world was new, every day was warm and perfect. But then the earth began to grow cold, and the animals felt the first winter. Snow began to fall, then fell thicker and faster each day until the animals were completely covered and started to fear for their lives. Finally Crow, who was beautiful and rainbow colored, volunteered to fly high into the sky and bring back the first fire. He did just that, but though he flew back to the earth as quickly as possible, the journey was still long. He arrived with the fire to save the animals from the cold, but the fire singed all his beautiful feathers and made his lovely voice harsh.

Rainbow Crow, while attributed to the Lenape people, may actually be an altered story from another people, such as the Cherokee, Shoshone, or Achomawi.

In a Cherokee story, Water Spider was the one to save the animals from the cold earth. She was the only one able to fetch fire from a sycamore tree that had been struck by lightning. In a Shoshone tale, the trickster Coyote stole fire from the cave of the fire people. In an Achomawi myth, Coyote asked Spider Woman to help him talk to Silver Gray Fox, who lived in the sky, and convinced him to return warmth to the land. In the myth, Spider Woman sent her two youngest children up on arrows shot by the animals and lifted up on winds made of song. Silver Gray Fox appreciated the visit and gifted the world with warmth, the first rainbow, and little morning dewdrop rainbows for all spider webs.

It is also possible that Rainbow Crow is a story that belongs to another tribe entirely, of which there is little or no record. Regardless, the story of a hero bringing fire to a cold land exists in many cultures across the world. Everyone dreams of warmth on a cold night.

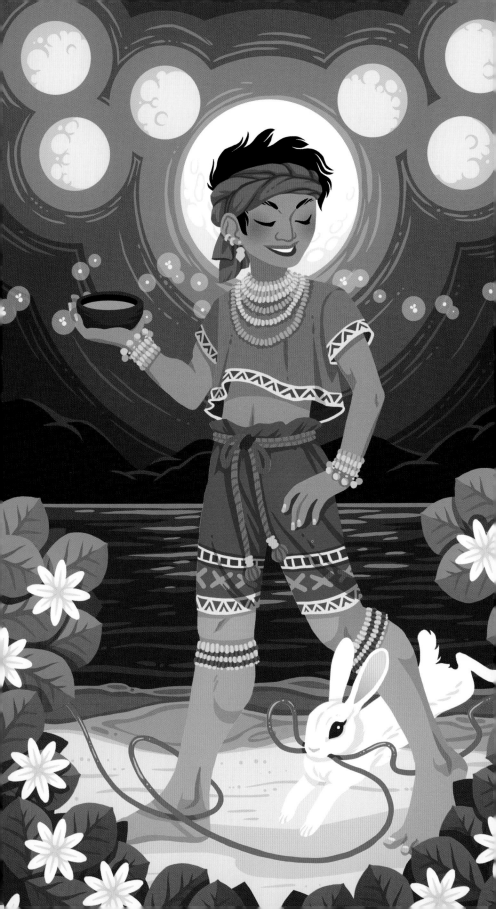

Bakunawa and the Seven Moons

The universe is split into seven planes. The lowest layer is empty and vast. The second layer is named Tubignon, and it is filled with water and the water spirits that live in the bottom of the ocean. The third layer is named Idalmunon and contains the dark underground earth and the spirits that live there. The fourth layer is named Lupan-on, and it is on this middle layer that humans live side by side with invisible spirits that cause sickness. The fifth layer is named Kahanginan, and it is the air right above people and is filled with flying air spirits. The sixth layer is named Ibabaw-non, and this is where *babaylan*, or shamans, ascend to in order to commune with spirits on behalf of people. The seventh layer is named Langit-non, and this is where the creator Maka-ako resides.

In the beginning, the night was long and dark, even on Langit-non. So Maka-ako decided to make light and created the seven sibling moons, each as fair and luminous as the last. The seven beautiful siblings lit up the night sky and were adored by all, including the sea serpent Bakunawa.

Bakunawa, who lived deep in the dark ocean, began to covet the brilliant moons. The serpent's lust became overwhelming, and Bakunawa leapt up from the sea and swallowed one of the moons whole. For a time, Bakunawa was able to rest beneath the waves, satisfied with the glowing moon inside it. But eventually the moon began to melt away, and Bakunawa craved a moon once more. The serpent leapt up and swallowed another moon and then leapt again to swallow yet another, showing no signs of stopping.

In some stories, Bakunawa swallowed every last moon and only spit out the last one in fright when the people of Lupan-on banged their drums and shouted at the serpent. And in some stories, the last moon stayed in the sky to fight while the remaining moons found their own happiness on Lupan-on. Maybe even aided by Tu'er Shen, the Chinese rabbit god of same-sex relationships who ties the red string of destiny between lovers.

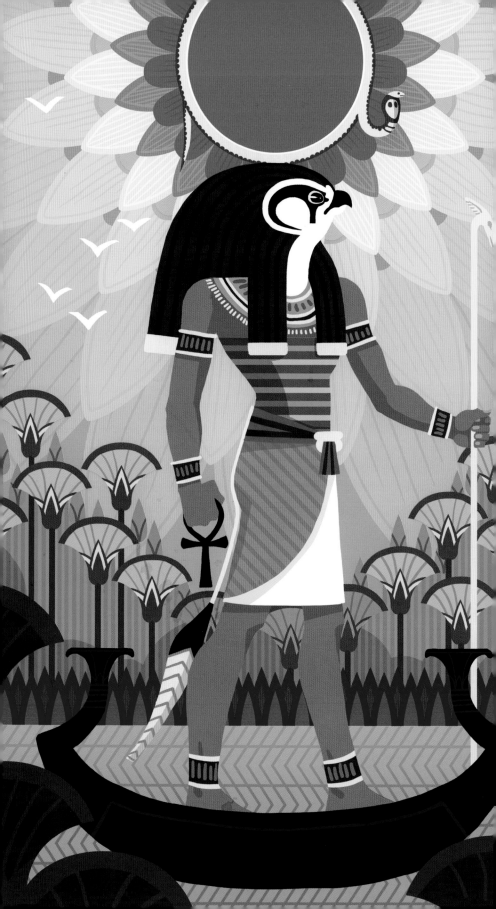

Sun God, Ra

EGYPT, EGYPTIAN DEITY

In the beginning, the sun god, Ra, emerged from the waters of Nun as a geometric Benben stone. The sun rose and passed across the sky for the first time. Ra was all-powerful and could take many forms. He was the morning sun Khepera at dawn, the full sun Ra at noon, and the evening sun Atum at sunset. His power was in his secret name and in his ability to call into being that which he named. And so he spoke the names of Shu and Tefnut, the god of air and the goddess of moisture. They in turn gave birth to the earth god, Geb, and the sky goddess, Nut. Ra tried to separate Geb and Nut by placing Shu between them, but Nut still managed to give birth to the deities Osiris, Set, Isis, Nephthys, and Horus the Elder. Ra proceeded to name all the things in Egypt, including the people, and set himself as pharaoh over all.

Thus, Ra ruled for some thousand years, but in the shape of a man, and so he grew old. Eventually humans began to mock his elderly appearance, which angered Ra. He then sent his daughter Sekhmet to slaughter humanity. She did so with such ease and relish that Ra began to pity the remaining humans. Ra stopped her rampage by throwing a party and getting her drunk. Meanwhile, the goddess Isis made a poisonous snake out of Ra's drool that would turn on him and bite him. Old and weak as he was, Ra began to die. Isis promised to heal him, but only if he revealed his secret name to her. He reluctantly did, and in that instant, he was healed and Isis became the goddess of life and magic.

By this time Ra was very old, and he decided to leave the ruling of the earth to humanity. He took his place in the heavens, traveling through the sky by day and crossing the underworld in a boat through the twelve divisions of Duat by night. Though it is a dangerous journey, each morning Ra is reborn by the goddess Nut.

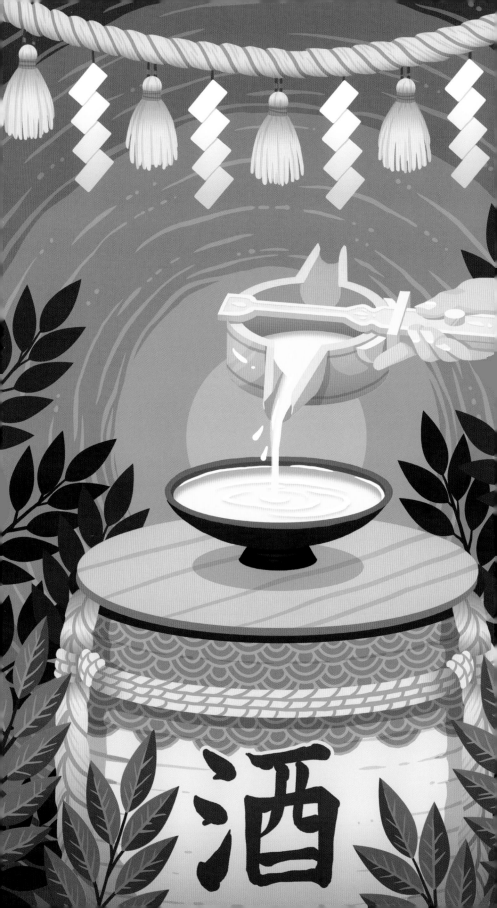

Matsuo's Sake

JAPAN, JAPANESE MYTHOLOGY

According to Shintoism, Japan is home to innumerable spirits or gods called *kami*. Some kami are smaller gods of tiny villages or specific cross-roads. Some kami are larger gods of cosmic forces, like the Sun or Moon, and some kami are whole mountains or significant rivers. Regardless of their importance, all kami gather once a year at Izumo Oyashiro shrine for a month during Kami-ari-zuki, or the month of the gods. While there, all the kami discuss important matters. For instance, this is when the kami of relationships, farming, and nation-building, called Okuninushi, decides the kinds of connections different people will have with each other for the following year. But it is also when all the kami come together to celebrate with each other.

One year, the kami Matsuo wanted to impress and delight the other gods. So he took rice from Arashiyama and water from Kyoto and brewed the very first sake. All the other kami loved it so much that it became the drink of the kami. Matsuo became the God of Sake, and many breweries began to worship him. But more important, sake became one of the best offerings to give a kami.

During festivals, people offer sake to kami in thanks and in celebration. The kami accept the gift and consecrate it so that the people can drink the sake and become even closer to the gods. Sake is used to banish evil and bless spaces, and it is even used in marriage ceremonies.

Sake is so powerful that all dragons covet it. The warrior-god, Susano-O, was able to defeat the eight-headed Yamata-no-Orochi, who had captured the beautiful maiden Kushinada-Hime by leaving out eight barrels of sake. Yamata-no-Orochi drank all of them and instantly passed out, allowing Susano-O to kill him and rescue Kushinada-Hime.

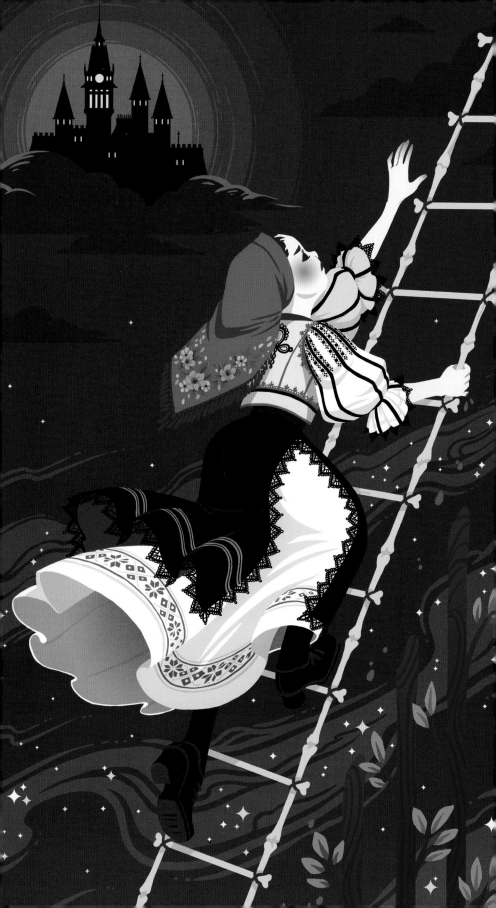

The Enchanted Pig

ROMANIA, ROMANIAN FAIRY TALE

Once upon a time, there was a king who had to go to war. He told his three daughters they were free to go anywhere in the castle except one particular room in one particular tower. They disobeyed him, and in the room they found a book that foretold that the eldest daughter would marry an eastern prince, the middle daughter would marry a western prince, and the youngest would marry a pig from the north. Shortly after the king returned, he discovered his daughters had read the book. Soon, an eastern prince married the eldest, a western prince married the middle, and a pig came to woo the youngest daughter.

At first the king refused the pig, and his city was soon overrun with pigs. The king was forced to consent. The princess married the pig and lived in his beautiful castle. Each night, he became a man and was so kind to her that she fell in love with him and wished to break his curse.

The princess encountered a witch, who told her to tie a thread to her husband's foot. But the princess didn't realize the witch was evil, and instead of breaking the curse, it solidified it. Her husband was then forced by the curse to flee, and the young princess chased after him.

The princess wore through three pairs of iron shoes and three walking staffs in her journey to find her husband. She asked for help from the Moon, the Sun, and the Wind, and they all gave her guidance and a sack of chicken bones. She arrived at the Milky Way and used the bones to form a ladder to climb to a castle in the sky where her husband was. Unfortunately, her ladder was one bone short, so she cut off her smallest finger with a dagger and used the bone to climb the last bit to the sky.

After the princess freed her husband from the castle, he revealed he was a prince who had killed a dragon. The dragon's mother was a witch who had cursed him, the same witch who then deceived the princess. The curse on the prince lifted as they climbed down from the sky. They then lived happily ever after.

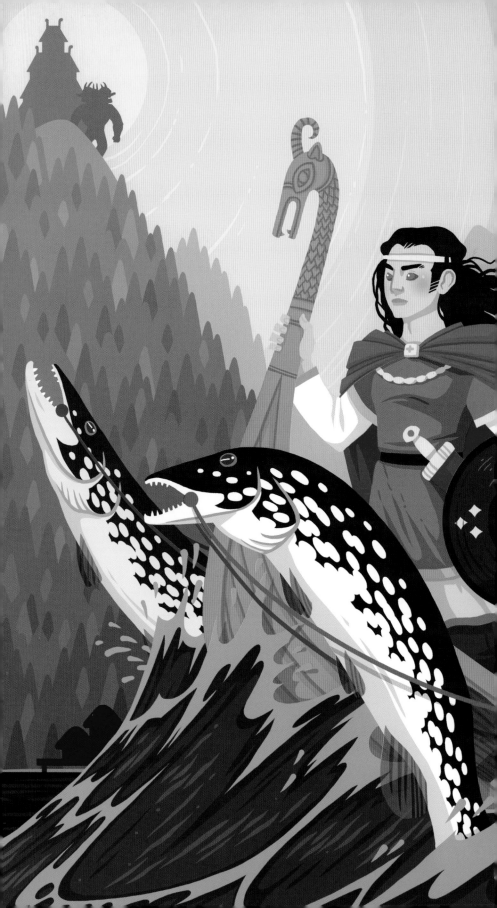

The Three Princesses of Whiteland

NORWAY, NORWEGIAN FAIRY TALE

One day a poor fisherman wasn't catching anything. Just as he was ready to give up, a fish poked its head out of the water and promised the fisherman plenty of fish if he promised what was beneath his wife's apron. The fisherman agreed and was happy with the bargain until he found out his wife was pregnant and he had just promised the fish his baby. The king of that country, finding out about this predicament, promised to raise the baby, a boy named Halvor, in his home away from the water. But when Halvor was grown, he felt the lure of the water. As soon as he set foot in a boat, it whisked him away to a distant place called Whiteland.

In Whiteland, Halvor met three beautiful princesses guarded by three trolls with three, six, and nine heads each. Through cunning and strength, he rescued all three princesses and married the youngest, who was the most beautiful. For a time, he lived happily with her in her castle with all her riches, but eventually he missed his parents. When he begged the princess leave to return home, she gave him a ring that would transport him twice—once there and once back. Finally, she made him promise to do only as his father asked, not as his mother wished. He agreed and was transported back.

When he arrived, his mother wished to take him to see the king, but his father asked that they not go. Ignoring his father, they went to the king and Halvor told his tale. When the king said he didn't believe the princess could be more beautiful than his wife the queen, Halvor grew prideful and used his ring to summon his wife to prove the king wrong. The princess appeared, scolded Halvor for breaking his promise, took back her ring, and transported herself back home.

Distressed, Halvor tried to get back to Whiteland, but no one knew where it was. Not any king, or animal, or bird. Everyone was asked until an old pike fish said he knew the way. The fish guided Halvor back to his princess, arriving just in time to stop her from marrying someone else.

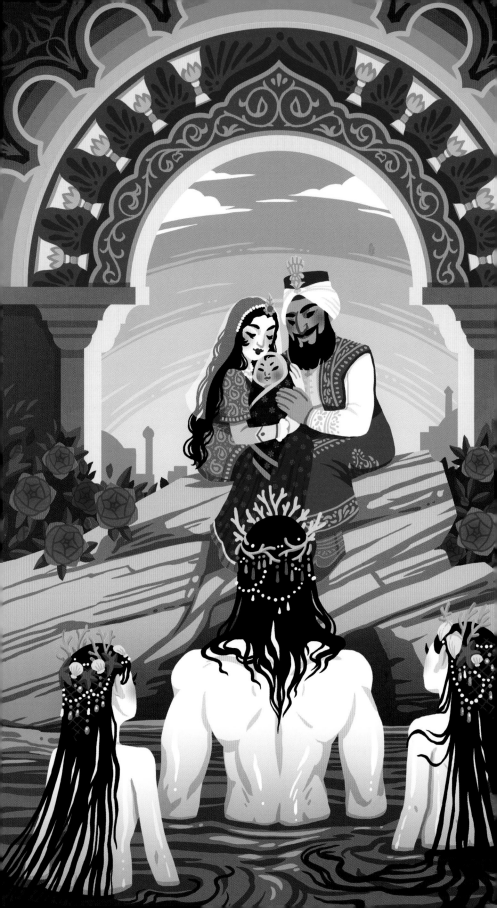

Julnar the Sea~Born

PERSIA, ARABIC FOLKTALE

There once lived a king of Ajam-land called Shahrimán. He had a hundred concubines, each more beautiful than the last, but none had given him a child. Shahrimán began to despair and worried he would never father an heir. It was at this time that a merchant appeared in his court, accompanied by the most lovely and graceful woman anyone had ever seen. She appeared otherworldly in all her perfection, and the king asked the merchant how much she cost, for he realized she was a slave. The merchant had bought her for a fair sum of money, and her upkeep over the past three years had been exorbitant. Yet, he intended to gift her to the king because he wanted to ensure she had a good home.

King Shahrimán accepted the merchant's gift and gave him a lovely cloak and more money than the merchant could have ever dreamed. The merchant was sent on his way. For a year, the king was devoted to the beautiful and mysterious woman. And for a year, though he gave her presents, served her lavish foods, and entertained her with music, she spoke not a single word. Finally, the king told her that, should she bear him a son, he would name her his queen, to which the woman smiled and said that she was indeed pregnant. The king rejoiced, for the woman with whom he had fallen in love had finally spoken to him, and he was soon to be a father.

Shahrimán asked the woman why she had not spoken, and she told her story. Her name was Julnar, and she was a princess of a sea kingdom, but she had had a disagreement with her brother and had climbed up on land. There she met a man who was vile and had almost killed him. However, she had also met the merchant, who was kind and virtuous, and he brought her to the king. Julnar told Shahrimán that if he hadn't treated her so well, she would have escaped to the sea long ago. With that, she reconciled with her family, and they helped her give birth to her son, Prince Badar Basim. Queen Julnar was crowned and lived happily with King Shahrimán and their son, being visited often by her sea-family.

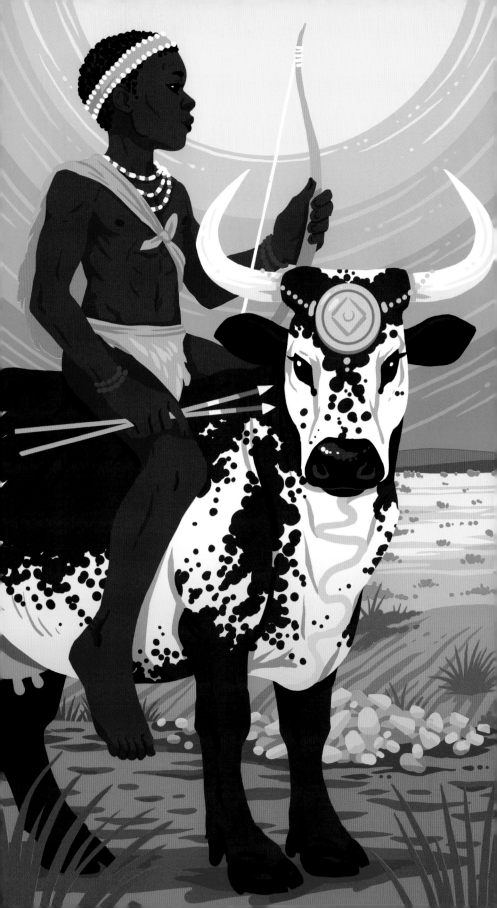

Heitsi-Eibib

Near the beginning of the world, there was a beautiful cow. One day while she was grazing, she found and ate some delicious magical grass, and a short time later she gave birth to Heitsi-Eibib. Heitsi-Eibib grew to be a man with incredible magic, unparalleled fighting skills, a quick wit, the ability to change his shape, and even the power to resurrect himself when he died. He walked upon the earth and used his powers to place the animals in their ideal environments, such as taking fish out of the desert and putting them into the sea and taking lions out of trees and placing them on the ground. In this way he became the god of the hunters.

Heitsi-Eibib traveled far and wide and soon became known for his strength and cleverness. He had a great many adventures, some where he was a hero and a few where he was a trickster. Around this time, there was a monster, Ga-gorib, who harassed the local people. They turned to Heitsi-Eibib for help. Ga-gorib had dug a giant pit and settled in beside it. He would then goad people into throwing rocks at him, but the rocks would magically rebound off him and hit the thrower, who would topple into the pit and die. By the time Heitsi-Eibib arrived, many people had died. Heitsi-Eibib was wise to the ways of Ga-gorib and waited for Ga-gorib to taunt him also. When Ga-gorib begged Heitsi-Eibib to throw rocks at him, he declined. Instead he pointed and shouted, "What's that?" and when Ga-gorib looked, Heitsi-Eibib hit him behind the ear and pushed him into his own pit, where he fell to his death. Peace returned to the people, and they celebrated Heitsi-Eibib.

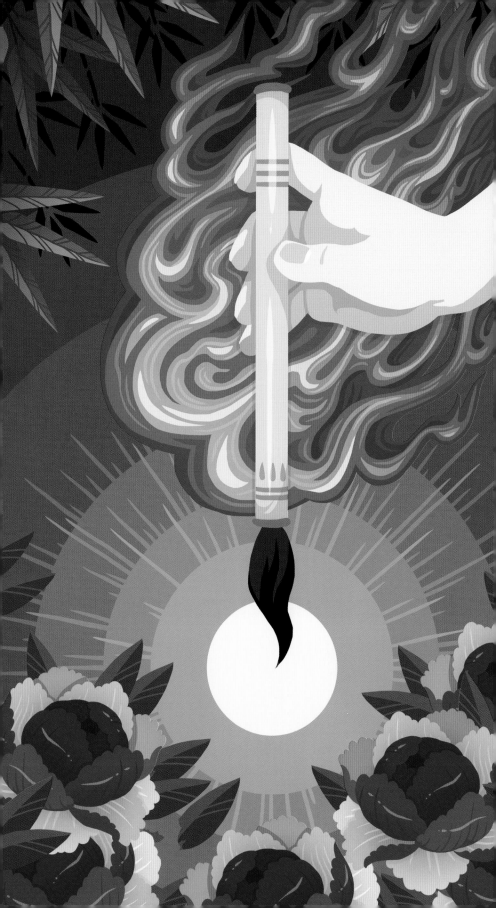

The Magic Paintbrush

CHINA, CHINESE FOLKTALE

There once was a very poor young man named Ma Liang who loved to draw very much. One night he had a dream that an old man gave him a magical paintbrush and asked him to help people. When he awoke, the magic paintbrush lay beside him.

Whatever Ma Liang drew with the magic paintbrush came into being, and he used its powers to benefit the struggling people around him. He used the brush to paint a river next to a dry field and to draw food for the poor. Quickly his fame grew, and everyone was grateful to Ma Liang.

In the same village lived a rich man who soon came to covet the magical brush. He didn't want to help people but instead wanted to paint gold and make himself even richer. In the dark of the night, he sent his servants into Ma Liang's home, and while Ma Liang was sleeping, they stole his brush.

The next day, the rich man painted many pictures of riches beyond belief. But no matter how many he drew, none of the images would come to life for him. Frustrated, the rich man ordered his guards to capture Ma Liang and bring him forward. When Ma Liang arrived, the rich man demanded that he draw for him or face punishment.

The quiet Ma Liang smiled and agreed. He asked the rich man what he would like, and the rich man said he wanted a mountain of gold. So Ma Liang painted a mountain, but he painted it in the middle of a vast sea. The rich man then demanded a large boat to sail the ocean with enough room in its hull to carry all the gold. So Ma Liang painted a huge sailboat, and the rich man and all his cronies got in it and set sail. But when they got halfway to the mountain, Ma Liang painted a wicked storm, and the boat capsized and all the men were lost at sea.

From that day on, Ma Liang and all the people of his village lived happy and peaceful lives.

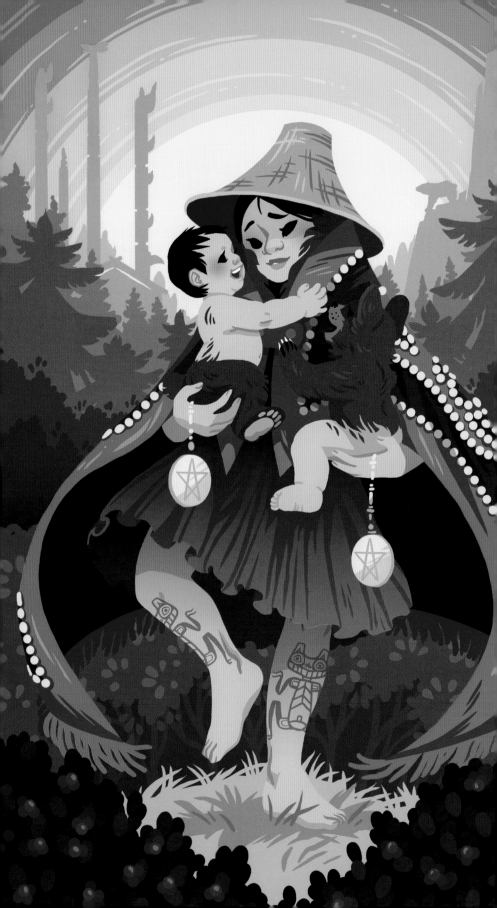

Rhpisunt

PACIFIC NORTHWESTERN NORTH AMERICA,
HAIDA MYTHOLOGY

A long time ago, there was Rhpisunt, the chief's beautiful daughter. One day she went out into the woods to pick berries and accidentally tripped over a pile of bear dung. She was indignant and began to loudly curse bears, calling them filthy and disgusting. The women she was with begged her to be quieter, but Rhpisunt would not be soothed, and they quickly left her. This was unfortunate because two bears happened to be nearby. They heard Rhpisunt's insults and felt she had to be punished. One of the bears transformed himself into a handsome young man and approached the irritated woman. He cajoled and seduced her and lured her back to his mountain home. There among the bear village, she fell in love with him and decided to live with him.

Rhpisunt and the handsome bear married and had twin boy cubs. The children were plump and healthy and had the ability to transform freely between bear and human. But all was not well. In the time since Rhpisunt had disappeared, her brothers had been searching tirelessly for her. In their investigations, they found her footprints beside those of a bear. In their fear and rage, they began to hunt down the bears.

Led by Rhpisunt's dog, the brothers managed to find Rhpisunt's bear husband. Overpowering him, they were able to deal him a mortal blow. With the last of his strength, the bear gave his wife his magical spells and formulas to pass on to their sons. And so Rhpisunt's brothers led her and her sons back to their tribe. There they lived as the twin boys grew up into men.

Although the twins were revered hunters and warriors, they were never comfortable among people. So when their mother died many years later as an old woman, the two transformed into bears and returned to the mountain woods, never to be seen again.

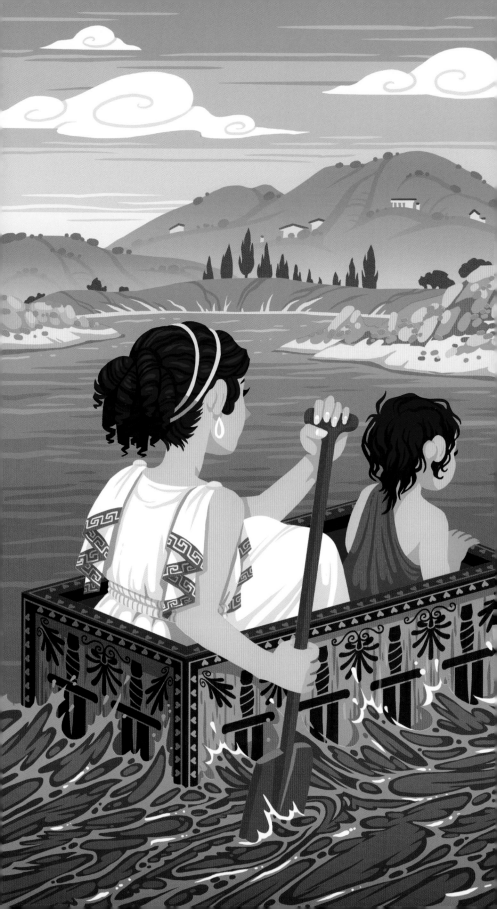

Danae and Perseus

GREECE, GREEK MYTHOLOGY

A long time ago in Argos lived King Acrisius and his only child, Princess Danae. When King Acrisius learned of a prophecy that he was destined to die at the hands of his daughter's son, he locked Danae deep underground in a chamber made of bronze so that no man could come near her. However, the god Zeus infiltrated her prison and, in the guise of a shower of gold, impregnated her. Danae then secretly gave birth to a son whom she named Perseus. When her father learned of this, he commanded Danae and the child Perseus be put in a chest and set in the sea.

Mother and child drifted but by the grace of the gods landed safely on the shores of the island of Seriphos. There the kind fisherman Dictys offered them sanctuary, and they lived in peace as Perseus grew up. Meanwhile, the ruler of Seriphos, King Polydectes, began to covet Danae. He saw Perseus as an impediment, so he sent him on a quest to retrieve Medusa's head.

Medusa was a Gorgon, a monster in the form of a woman with snakes growing from her head. Her appearance and her stare were so frightening that all who saw her turned to stone. Perseus was able to defeat her by using a mirror to avoid looking at her directly. He chopped off her head and put it in a bag, returning to Seriphos a hero. Unfortunately, the king never expected Perseus to return, and Danae, repulsed by Polydectes, had fled to the temple of Athena. Furious at the mistreatment of his mother, Perseus used the Gorgon's head to turn Polydectes into stone.

Perseus then retrieved his mother, and together they returned to Argos. King Acrisius, terrified that he would die at the hands of his grandson, exiled himself instead. But at the games commemorating the exiled king, Perseus threw a discus that flew astray and hit Acrisius, killing him instantly.

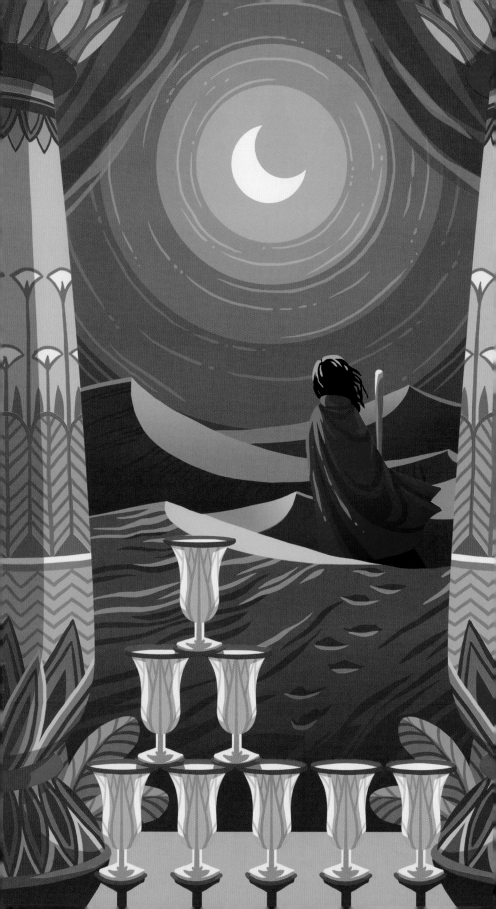

Moses

Long ago, the Jewish people were slaves in Egypt, forced to work for the Egyptians. The Pharaoh began to fear that they might overthrow him, and so he ordered all the baby boys born during a certain time to be killed. Yocheved feared for her son, Moses, so she put baby Moses in a basket and sent him down the river. As he floated in the water, he was found by Pharaoh's daughter, who raised Moses as her own. After he had grown into a young man, Moses realized his true lineage and killed a slave master who mistreated a Jewish slave. He then decided to leave the riches of the palace and flee to a humbler life across the sea.

In Midian, Moses met and married a Kenite woman named Zipporah. They lived happily until God told Moses, through a burning bush, to go back to Egypt, liberate the Jewish people, and bring them to the chosen land. Moses reluctantly agreed.

Upon returning to Egypt, Moses demanded Pharaoh set the Jewish people free, and when Pharaoh refused, God sent down ten plagues. First the Nile River was turned to blood, killing all the fish. Then the country was beset by an infestation of frogs. Then everyone became covered in lice, followed by flies, then all the livestock died of sickness. People began breaking out in boils, and fire came raining down from the sky. Locusts ate all the crops, then the world became dark for three days. Finally, with the last plague, all the firstborn sons in Egypt died. But the firstborn sons of the Jewish people were spared because the families were warned ahead of time by Moses to mark their door frames with lamb's blood.

Pharaoh, heartbroken at the death of his own son, ordered Moses and all the Jewish people to leave Egypt. But when Moses parted the Red Sea to create a path for the Jewish people to cross, Pharaoh changed his mind. He ordered his army to chase down the fleeing Israelites. After the last of the Jewish people crossed, Moses closed the sea on the Egyptian army, drowning all of them. And so Moses and the Jewish people were free.

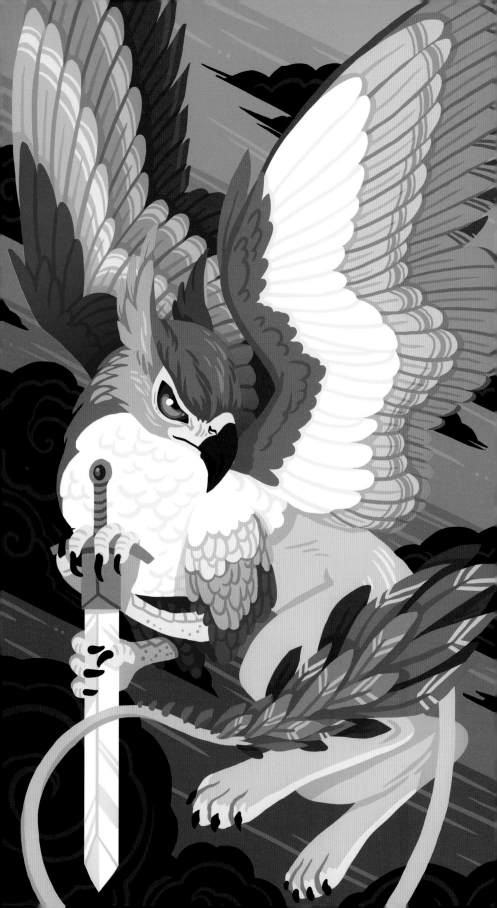

Griffin

Griffins are giant hybrid creatures, part lion and part eagle. As griffins are the kings of both animals and birds, their majesty and power represent wisdom and strength in war. Their claws have medicinal properties, and their feathers can cure blindness. They guard treasure, and wherever a griffin is found, gold deposits are sure to be nearby. They even build nests of the gold they dig out of rocks. Pliny the Elder, a Greek historian, wrote of how the one-eyed warrior Arimaspian people constantly waged war with the griffins that lived near them. The warriors lived near the foot of the Rhipaion mountains in northern Skythia and fought continually with the griffins, who defended their rivers of gold.

Griffins also mate for life. Strictly loyal to their partners, they will not take a new mate even if their significant other dies. So they have come to represent monogamous unions and unwavering devotion. Their mixture of sky and ground animals means they are able to traverse both the air and the land, representing the connection between heaven and the earth, the divine and the human.

Griffins have traveled far and wide. They have been found in paintings and sculpture since ancient times in Iranian art and even ancient Egyptian works. Griffins have also been documented in Syria, Anatolia, and Greece. They are in the frescoes of the throne room at the palace of Knossos on Crete. They have been recorded as far east as Central Asia and India. They also appear frequently in the heraldry of Western Europe.

Griffins are also sometimes depicted as the creatures that pull Apollo's chariot. Apollo is the Greek god of healing, medicine, archery, poetry, and music. One of the twelve Olympians and the most powerful of the pantheon of gods, he originally only watched after the sun god Helios's cattle. But eventually he became the god that pulled the sun across the sky each day, with flying griffins, stronger than oxen, pulling his chariot.

Sister Alyonushka and Brother Ivanushka

RUSSIA, RUSSIAN FAIRY TALE

There once was an orphaned girl named Alyonushka, who lived with her young brother, Ivanushka. Ivanushka was still too young to work, so he would follow his sister to her job on the other side of the forest. The journey was long and hot for the young boy, so when he saw a cow hoofprint filled with water, he asked his sister if he could drink from it. She told him to wait until they could drink from the well. He asked again when he saw another hoofprint—this time a horse's—filled with water, and again she told him to wait for the well. By this time he was so hot and thirsty that when he saw a goat hoofprint filled with water, he didn't ask. He just drank. Immediately he was transformed into a little white goat, for the water had been a witch's trick.

Alyonushka, realizing what had happened to her brother, began to cry. She vowed to take care of him forever. Just then a merchant came riding by and saw the lovely Alyonushka on the side of the road with a baby goat by her side. He asked her why she was crying, and when she told him her story, he instantly fell in love with her purity and proposed to her right then and there. Alyonushka agreed and they were soon wed, and the three lived happily for some time.

However, one day a witch kidnapped the goat-brother and used him to lure Alyonushka to the river. The witch seized the girl, tied her up, and weighted her with stones before throwing her into the water. Ivanushka managed to escape the witch. He ran home and found that the witch had transformed herself to look like Alyonushka. Alyonushka's husband, who had been away during this adventure, did not notice any difference in his wife. The disguised witch tried to convince the merchant to eat the goat. But Ivanushka instead led him to the river to discover and save the real Alyonushka. Knowing they had been deceived by the witch, Alyonushka and her husband killed her, breaking the curse on Ivanushka. To their delight, he became a human boy once again.

Janus

ITALY, ROMAN MYTHOLOGY

Janus is the Roman god of beginnings, gates, time, passages, journeys, and endings. He is a god of transitions, always having one face looking forward to the future and one looking back to the past. He is particularly important to travel, trade, and shipping, especially when associated with Portunus, the god of harbors.

Janus is an unusual god because he was a mortal man first. The story begins with Saturn, a god of agriculture and great power. He ruled from Capitoline Hill until he was overthrown by his son, Jupiter, who then became the king of all the gods. Fleeing from his son's wrath, Saturn sought refuge in Latium and with the king of Latium, who was Janus. Janus welcomed Saturn with open arms, so Saturn made Latium successful in its agriculture, especially viticulture, the production of grapes. In return, Janus gave Saturn half his kingdom, and they ruled together peacefully. Latium saw great prosperity under their rule, a true golden age, eventually becoming the city of Rome in the center of the Roman Empire. As a reward, Janus became the god of gates and the god to connect people with all the other deities of the Roman pantheon.

Janus also became the protector over the beginning of all activities. He inaugurated the seasons, and the first day of each month was sacred to him. He was the gatekeeper, the protector of passages and endings, and the deity of duality. He became so important to the Romans that they built him five separate shrines in the city of Rome alone. All the shrines were built near crossings of rivers or watercourses. The most impressive shrine was the one near the Argiletum. The temple had a statue of Janus in the middle, where offerings of wine were given, and large bronze doors on either end, which were open during times of war and closed during times of peace.

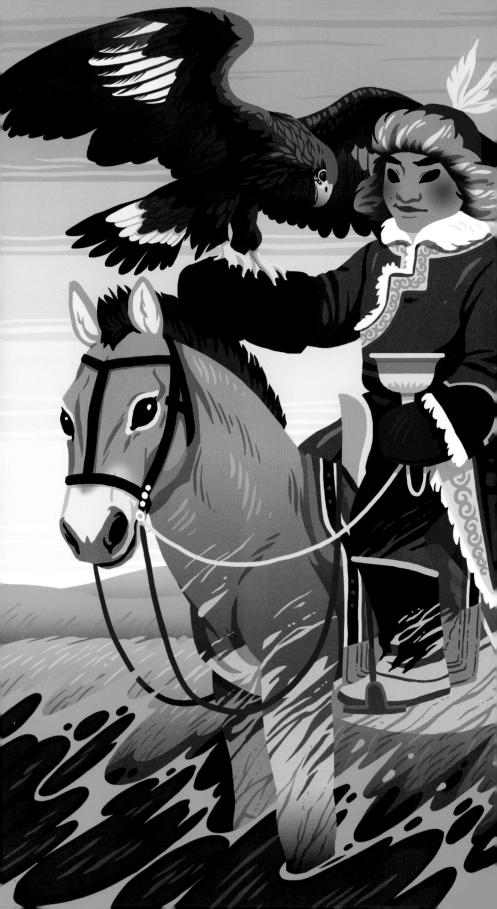

Halibu the Hunter

On the Mongolian steppes, there once was a hunter named Halibu. He was highly skilled and caught much game, but he was also very kindhearted, readily sharing his meat with everyone. Therefore, he was widely respected.

One day while hunting, he heard strange sounds and looked up to see a small creature in the beak of a fierce bird. He shot the bird down with his arrow and was surprised to see a small snake-like creature freeing itself from the bird, but he was even more surprised when the creature thanked him for saving her. She said she was the daughter of the dragon king and that if he followed her, the king would offer Halibu many treasures. She suggested he ask for the stone in the king's mouth, a magical stone that would allow Halibu to understand the languages of all animals.

The princess took Halibu to her father, and the dragon king was delighted to see his daughter safe and offered Halibu any treasure he desired. The hunter decided he didn't need treasure, but he asked for the magical stone to understand the languages of animals. The king was surprised but agreed on the condition that Halibu never tell anyone what he heard the animals say, or he would be turned into a rock immediately.

With the stone in his mouth, Halibu brought home even more game. But one day he heard a flock of birds discussing an upcoming disaster. They predicted that the mountain would collapse and the plain would flood that night, drowning everyone, including Halibu's home.

Halibu dashed home to warn his people, but none of them would believe him no matter how insistent he was. They said moving was difficult and demanded proof. He reluctantly told them about the dragon king, the magical stone, and the birds' conversation he overheard. As he spoke, he began to turn to rock, and when he finished, he had become completely solid.

The stunned people believed him and hurriedly collected their things. They barely managed to escape before the mountain collapsed and the area flooded. To this day the descendants of Halibu's people thank him and search for his rock.

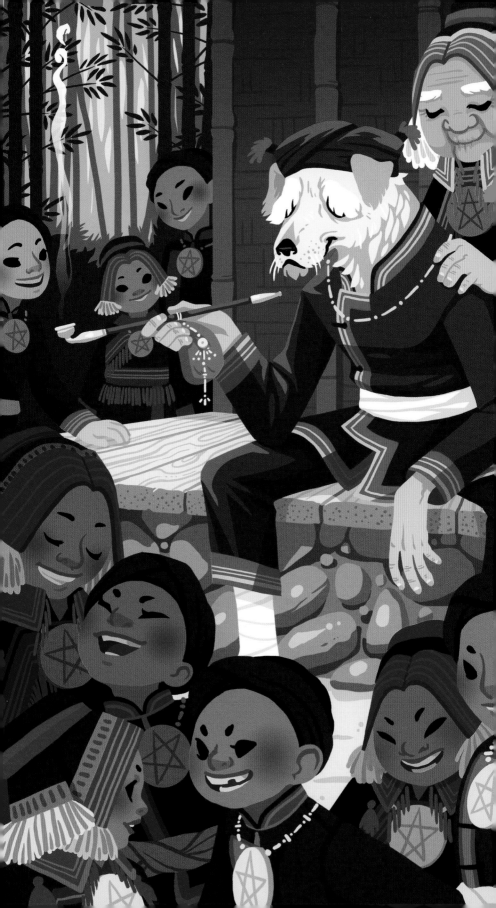

Pan Hu

CHINA, YAO PEOPLE

A long time ago, the empress of China had an earache so terrible she sent for her physicians. From her ear they pulled a tiny gold worm, and her pain went away immediately. Instead of killing the creature, the empress set it on a plate under a jar and gave it a little food and water. When she next checked in on it, it had become a small dog. She named the dog Pan Hu, and he soon became a favorite of the emperor, following the ruler wherever he went. So Pan Hu was one of the first to hear about the enemy king who planned to go to war with the emperor.

The emperor put out a proclamation promising his daughter's hand in marriage to whoever could bring him the head of the enemy king. But the king was a terrible warrior, and no one was able to kill him. Pan Hu took matters into his own paws: he snuck into the enemy's castle, and when the king was drunk from a night of partying, Pan Hu cut off his head. The dog returned with the head of the king, and the emperor then threw a great feast in his honor. But Pan Hu only sulked, and the emperor realized he wanted the promised reward of marriage to the princess.

The emperor explained that a human princess could not marry a dog. Pan Hu said that this problem could be fixed. He bade the emperor place him under a giant golden bell and not have anyone look at him for seven days. The emperor did this, and for six days the bell rested undisturbed. On the seventh day, the princess began to worry for Pan Hu, thinking he must be hungry and thirsty. She brought him food and drink and lifted the bell only the tiniest bit, but it was enough to break the spell.

Pan Hu emerged with the body of a man and the head of a dog. But the emperor still honored the union, and Pan Hu and the princess married and went on to have many, many children and even more descendants.

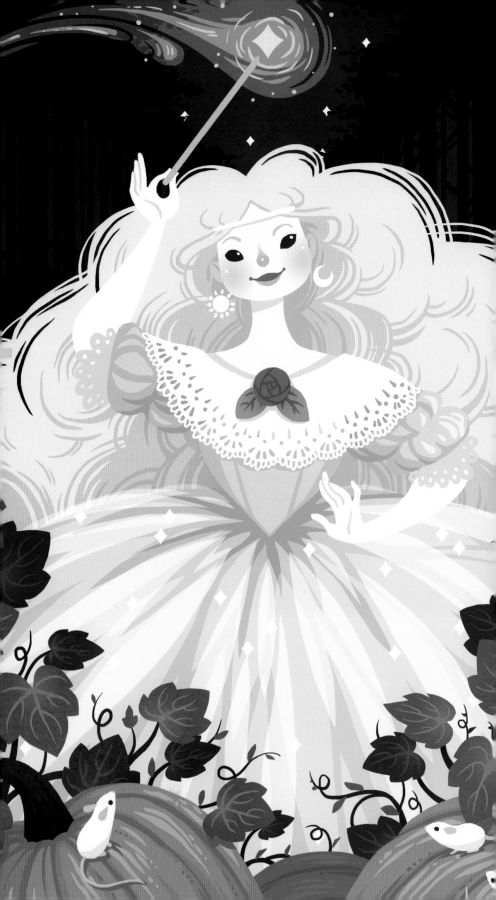

The Fairy Godmother

FRANCE, FRENCH FAIRY TALE

The Fairy Godmother is a helpful creature who has supported many heroes and heroines, none more famously than Cinderella.

Cinderella was a beautiful girl whose kind mother died when Cinderella was very young. After remarrying a cold woman with two bitter daughters, Cinderella's father died also. This left Cinderella orphaned and in the care of her resentful stepmother. Angry that Cinderella was more beautiful than her own daughters, the stepmother put Cinderella to work mending the laundry, cleaning the house, and doing all the cooking. Each night, Cinderella slept in the ashes of the kitchen fireplace and became filthy.

Quiet Cinderella bore all this abuse patiently until she heard about the upcoming royal ball. It was to be a night of celebration, with all the young ladies of the country invited to meet the prince. Cinderella wished to go to the party, but when she asked her stepmother and stepsisters, they all laughed in her face. For who would want to dance with a dirty girl covered in ashes? Cinderella cried as her stepfamily put on their beautiful gowns and rode away to the ball. It was then that the Fairy Godmother, hearing Cinderella's sobs, appeared to help her.

The Fairy Godmother told Cinderella that because her heart was sweet and pure, she would help her by turning a pumpkin into a carriage, mice into horses, rags into a ball gown, and dirt into glass slippers. But, she warned, the spell would break at midnight. And the rest was up to Cinderella.

Gleefully, Cinderella rode to the ball and met the prince. He was instantly dazzled by her and she by him, and they danced the night away. At midnight, Cinderella remembered the Fairy Godmother's warning and fled the ball, leaving behind a broken pumpkin and a single glass slipper.

The prince began a search for the mysterious girl, insisting every young lady in the realm try on the glass slipper. But it didn't fit anyone, until it was finally slipped on the ash-covered foot of Cinderella. Rejoicing, the prince and Cinderella were soon married, and the Fairy Godmother blessed their union.

About the Author

Yoshi Yoshitani is an illustrator based in California who has done work for The Walt Disney Company, Image Comics, Valiant Comics, IDW Publishing, DreamWorks Animation, and Rebellion Publishing. Illustrator of the graphic novel *Zatanna and the House of Secrets*, Yoshi is currently working on a young adult graphic novel for DC Comics. Yoshi regularly appears on panels at comic book conventions such as Emerald City Comic Con, New York Comic Con, C2E2, HeroesCon, LightBox Expo, WonderCon, DesignerCon, Thought Bubble, and Dragon Con. Yoshi's favorite stories include "The Bear King, Valemon," "Tam Lin," and any story with a trickster character.

Index

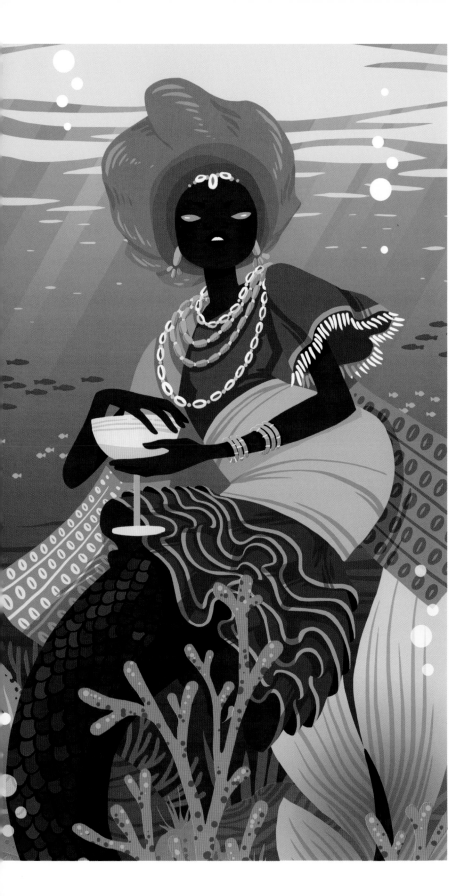

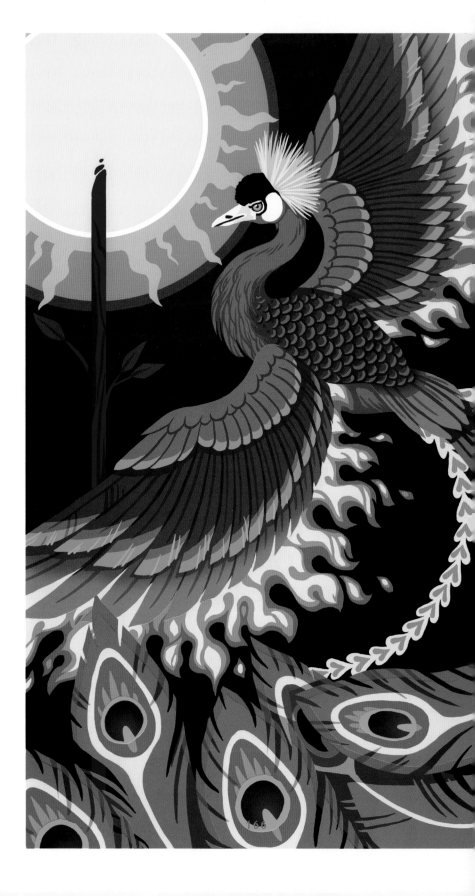

Library of Congress Cataloging-in-Publication Data
 Names: Yoshitani, Yoshi, artist.
 Title: Beneath the moon : fairy tales, myths, and divine stories
 from around the world / Yoshi Yoshitani.
 Other titles: Fairy tales, myths, and divine stories from around the world
 Description: First Edition. | California : Ten Speed Press, 2020. | Includes index.
 Identifiers: LCCN 2020001866 (print) | LCCN 2020001867 (ebook) |
 ISBN 9781984857224 (Hardcover) | ISBN 9781984857231 (eBook)
 Subjects: LCSH: Folklore. | Mythology.
 Classification: LCC GR71 .B464 2020 (print) | LCC GR71 (ebook) |
 DDC 398—dc23
 LC record available at https://lccn.loc.gov/2020001866 LC ebook record
 available at https://lccn.loc.gov/2020001867

Printed in China

Hardcover ISBN: 978-1-9848-5722-4
eBook ISBN: 978-1-9848-5723-1

Design by Kelly Booth

10 9

First Edition